Ecological
Houses

teNeues

Imprint

Editor: Viviana Guastalla

Texts: Sarah Rich

Cover photo (location): Andreas Keller (House in the Schurwald)

Back cover photos from top to bottom (location): k_m architektur (House with Panoramic View), Oliver Schuster (Philipp House), Markus Tretter/Lindau (House at Lake Constance), Eibe Sönnecken (Opus House), Cristobal Palma (Wall House)

Introduction photos (page, location): Kenneth M. Wyner (pages 3, 11, Slavin/Arnholz Residence; page 9, The Linnean Family), Brett Boardman (page 4 Pirates Bay House), Tom Rider (page 5, Sonoma Coast House; page 7, Oregon Coast House), Sharon Risedorph (page 6, Canal House), Marla Aufmuth (pages 8, 10, Courtyard House)

Layout: Viviana Guastalla

Pre-press & Imaging: Kerstin Graf, Jan Hausberg

Translations: Alphagriese Fachübersetzungen, Dusseldorf

Copy editing of French, Italian and Spanish texts: Dr. Suzanne Kirkbright / Artes Translations, UK

Produced by fusion publishing GmbH, Stuttgart . Los Angeles www.fusion-publishing.com

Published by teNeues Publishing Group

teNeues Verlag GmbH + Co. KG
Am Selder 37
47906 Kempen, Germany
Tel.: 0049-(0)2152-916-0
Fax: 0049-(0)2152-916-111
E-mail: books@teneues.de

teNeues Publishing Company
16 West 22nd Street
New York, NY 10010, USA
Tel.: 001-212-627-9090
Fax: 001-212-627-9511

teNeues Publishing UK Ltd.
P.O. Box 402
West Byfleet
KT14 7ZF, Great Britain
Tel.: 0044-1932-403509
Fax: 0044-1932-403514

teNeues France S.A.R.L.
93, rue Bannier
45000 Orléans, France
Tel.: 0033-2-38541071
Fax: 0033-2-38625340

Press department: arehn@teneues.de
Tel.: 0049-(0)2152-916-202

www.teneues.com

ISBN: 978-3-8327-9227-5

© 2008 teNeues Verlag GmbH + Co. KG, Kempen

Printed in Italy

Bibliographic information published by Die Deutsche Bibliothek.
Die Deutsche Bibliothek lists this publication in the Deutsche Nationalbibliografie; detailed bibliographic data is available in the Internet at http://dnb.ddb.de.

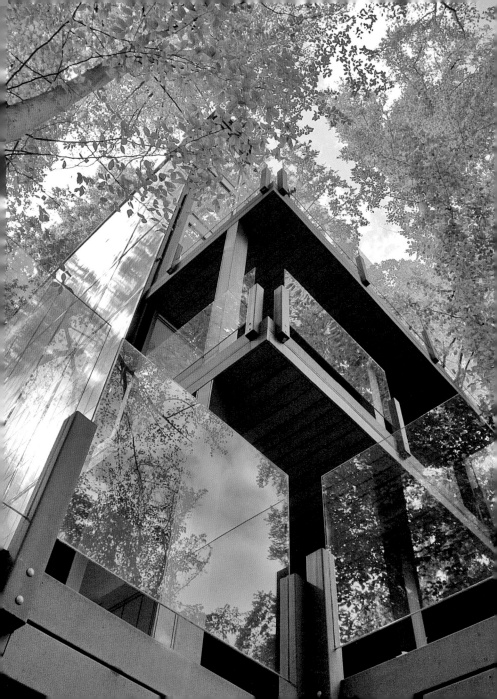

Introduction . 6

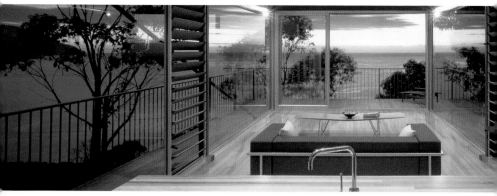

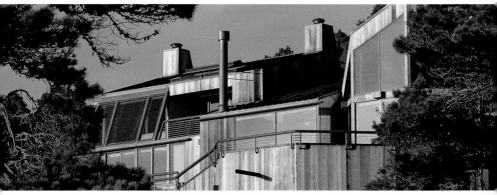

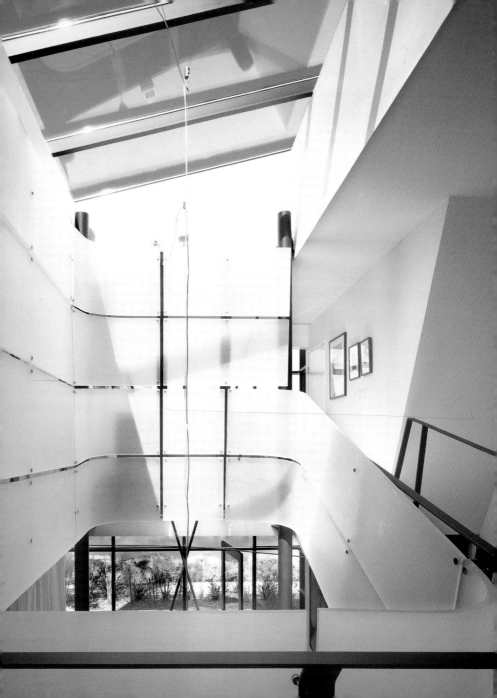

Introduction

As climate change intensifies, we are learning to change our habits and our minds. Sustainable technological developments gain a steadily increasing importance. This is especially remarkable in the field of ecological housing where utilizing salvaged materials and the resourcing sustainable materials are the challenges of today architects and designers.

Several decades ago, having an environmentally-sensitive home meant giving up elements of comfort as well as elegance. Today, based on ingenious designs and intelligent applications of technology, many architects, engineers and designers are developing innovations that make a sustainable lifestyle possible without sacrificing the features of a cozy and stylish home. Their improvements in environmental solutions come, in part, from looking back to age-old principles of architecture, and also from looking ahead toward the potential of advancements in technology.

Before HVAC and power grids, we were inventive with low-tech solutions. Today, the addition of digital and industrial processes allow us to create responsive devices and low-impact materials that enhance and streamline sustainable products. We now have new environmental friendly solutions, such as integrated solar panels, prefabricated insulation, and underground rain collection tanks, that improve efficiency and reduce waste without disrupting architectural integrity. Further more, these options are also more economical with long term use.

Ecological Houses explores 32 residential projects from around the world each of which strikes a balance between high- and low-tech solutions for energy efficiency and sustainability. The architects for these featured projects come from an emerging culture of aesthetically and environmentally forward-looking designers whose ideas reflect the eco-friendly building design fundamentals of past civilizations. Their work is an elegant testament to the tremendous potential of ecological architecture transforming the way we live for the better.

Sarah Rich

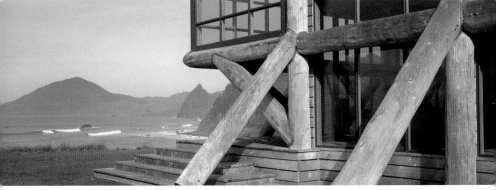

Einleitung

Bedingt durch die immer deutlicher werdenden Auswirkungen des Klimawandels, beginnen wir unsere Gewohnheiten und Denkweisen zu ändern, und nachhaltige technologische Entwicklungen gewinnen stärker an Bedeutung. Dies ist besonders spürbar im Bereich ökologischer Wohnarchitektur, wo die Verwendung von Materialien aus erneuerbaren Ressourcen und umweltverträglicher Baustoffe die Herausforderungen der Architekten und Designer von heute sind.

Noch vor einigen Jahrzehnten war der Besitz eines umweltfreundlichen Hauses gleichbedeutend mit dem Verzicht auf Komfort und Stil. Heutzutage entwickeln jedoch viele Architekten, Ingenieure und Designer mit kreativen Ideen und der intelligenten Anwendungen moderner Technologien Neuerungen, die einen umweltfreundlichen Lebensstil ohne den gleichzeitigen Verzicht auf die Annehmlichkeiten eines gemütlichen und eleganten Heims ermöglichen. Ihre verbesserten nachhaltigen Lösungen resultieren teilweise aus der Rückbesinnung auf uralte Architekturprinzipien sowie der Einbeziehung der Möglichkeiten des technologischen Fortschritts.

Bevor es HVAC und Stromnetze gab, waren wir erfinderisch in Low-Tech-Lösungen. Heute können wir dank der Anwendung digitaler und industrieller Prozesse bedarfsgerechte Geräte und belastungsarme Materialien kreieren, die umweltfreundliche Produkte verbessern und rationalisieren. Uns stehen neue, umweltschonende Lösungen zur Verfügung, wie zum Beispiel integrierte Sonnenkollektoren, vorgefertigte Dämmstoffe und unterirdische Tanks zum Auffangen von Regenwasser, welche die Wirtschaftlichkeit verbessern und den Abfall reduzieren ohne die architektonische Einheit zu stören. Bei einer Langzeitnutzung sind diese Optionen zudem ökonomischer.

Ecological Houses stellt 32 Wohnprojekte aus aller Welt vor, die gekonnt die Balance zwischen High- und Low-Tech-Lösungen für Energieeffizienz und Umweltfreundlichkeit halten. Die Architekten dieser ausgewählten Projekte gehören zu einer neuen, fortschrittlichen Generation ästhetisch und umweltfreundlich orientierter Designer, deren Ideen die ökologisch wertvollen architektonischen Errungenschaften früherer Zivilisationen wieder aufnehmen. Ihre Arbeit ist ein elegantes Zeugnis des enormen Potentials, das in ökologischer Architektur steckt, um unser Leben positiv zu verändern.

Sarah Rich

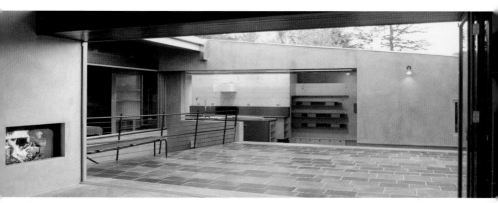

Introduction

Avec l'intensification du réchauffement climatique, nous apprenons à changer nos habitudes et nos états d'esprit. Le développement technologique durable acquiert une importance toujours croissante. Cela est particulièrement visible dans le domaine de l'habitation écologique où l'utilisation de matériaux de récupération et le renouvellement des matériaux durables sont les défis qui se posent aux architectes et aux designers d'aujourd'hui.

Il y a plusieurs décennies, posséder une maison écologique signifiait dire adieu aux éléments de confort et à l'élégance. Aujourd'hui, grâce à des designs ingénieux et une application intelligente des technologies, de nombreux architectes, ingénieurs et designers proposent des innovations qui rendent possible un mode de vie durable sans pour autant sacrifier les caractéristiques d'une maison douillette et coquette. Les améliorations qu'ils apportent aux solutions écologiques proviennent, en partie, d'un retour sur les principes séculaires de l'architecture, et aussi, d'une vision vers l'avenir et le potentiel des progrès technologiques.

Bien avant le CVC et les réseaux électriques, nous faisions preuve d'inventivité avec des solutions traditionnelles, low-tech. Aujourd'hui, l'arrivée des procédés numériques et industriels nous permet de créer des appareils réactifs et des matériaux avec peu d'impact qui enrichissent et rationnalisent les produits durables. Nous possédons maintenant de nouvelles solutions écologiques, comme les panneaux solaires intégrés, l'isolation préfabriquée et les réservoirs souterrains de collecte des eaux, qui améliorent l'efficacité et réduisent les déchets sans perturber l'harmonie de l'architecture. Bien plus, ces nouvelles options sont également plus économiques à long terme.

Ecological Houses vous fait découvrir 32 projets résidentiels du monde entier, chacun parvenant à un équilibre entre les solutions high-tech et low-tech pour l'efficacité énergétique et la durabilité. Les architectes de ces projets sont issus d'une culture émergente de designers novateurs sur les plans esthétique et environnemental, dont les idées reflètent les fondamentaux écologiques de construction des civilisations passées. Leur travail est un témoignage du formidable potentiel de transformation dont dispose l'architecture écologique pour rendre nos modes de vies meilleurs.

Sarah Rich

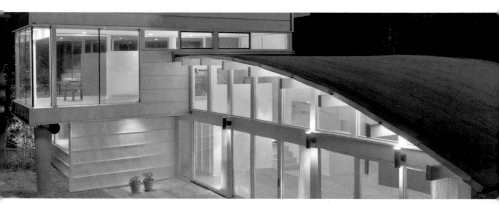

Introducciòn

A medida que se intensifica el cambio climático, vamos aprendiendo a transformar nuestros hábitos y forma de pensar. El desarrollo tecnológico sostenible está ganando importancia de modo constante. Un hecho que se hace patente en el campo de la construcción de viviendas ecológicas, donde el empleo de restos de materiales y de materias ecológicas constituye todo un reto para los arquitectos y diseñadores de hoy.

En décadas pasadas, tener una vivienda respetuosa con el medio ambiente suponía renunciar tanto al confort como a la elegancia. Actualmente, son muchos los arquitectos, ingenieros y diseñadores que, apoyándose en diseños brillantes e inteligentes aplicaciones tecnológicas, desarrollan innovaciones que posibilitan un estilo de vida sostenible, sin sacrificar para ello los elementos esenciales de un hogar acogedor y con estilo. Sus progresos a la hora de aportar soluciones ecológicas son en parte el resultado del regreso a principios arquitectónicos ancestrales, así como la mirada al futuro y el potencial de los avances tecnológicos.

Antes de que existiera la calefacción, el aire acondicionado, o el tendido eléctrico, la capacidad inventiva del ser humano buscaba soluciones con tecnología rudimentaria. Hoy en día, gracias a los procesos industriales y las soluciones digitales, podemos elaborar dispositivos eficaces y materiales poco contaminantes que ayudan a mejorar y perfeccionar los productos ecológicos. Contamos con nuevas soluciones respetuosas con el medio ambiente, tales como los paneles solares integrados, el aislamiento con prefabricados o las cisternas subterráneas de almacenamiento de aguas pluviales; todas ellas favorecen la eficiencia energética y reducen la producción de residuos sin dañar la integridad arquitectónica. Asimismo, a largo plazo estas opciones resultan económicamente más rentables .

Ecological Houses explora 32 proyectos residenciales de todo el mundo. Cada uno de ellos encuentra el equilibrio entre las soluciones de alta tecnología y otras más tradicionales, en aras de la eficiencia energética y la sostenibilidad. Los arquitectos de estos proyectos provienen de una cultura emergentè de diseñadores vanguardistas en cuestiones estéticas y medioambientales. Sus ideas reflejan principios de diseño arquitectónico respetuosos con el medio ambiente ya existentes en civilizaciones pasadas. Su obra constituye un refinado testimonio del enorme potencial de la arquitectura ecológica, en vías a transformar y mejorar nuestro estilo de vida.

Sarah Rich

Introduzione

Con l'intensificarsi del cambio climatico, stiamo imparando a cambiare abitudini e mentalità. Gli sviluppi delle tecnologie sostenibili assumono un'importanza sempre crescente. Ciò si può notare in particolare nel campo delle abitazioni ecologiche, dove l'utilizzo di materiali di recupero ed ecologicamente sostenibili rappresentano una sfida per i moderni architetti e designer.

Vari decenni or sono, vivere in una casa sensibile dal punto di vista ambientale comportava la rinuncia a comfort ed eleganza. Oggi, sulla base di ingegnosi progetti ed intelligenti applicazioni tecnologiche, numerosi architetti, ingegneri e designer sviluppano innovazioni che rendono possibile uno stile di vita sostenibile senza sacrificare i piaceri di una casa accogliente ed elegante. I perfezionamenti nelle soluzioni ambientali derivano in parte da una rivisitazione di antichi principi architettonici, così come dal guardare avanti verso i potenziali del progresso tecnologico.

Prima dei climatizzatori e delle reti energetiche, ci si arrangiava con soluzioni rudimentali. Oggi l'aggiunta di processi digitali ed industriali permette di creare installazioni adeguate e materiali a basso impatto, che agevolano e favoriscono i prodotti sostenibili. Ora disponiamo di nuove soluzioni orientate all'ambiente, come pannelli solari integrati, isolamenti prefabbricati, cisterne sotterranee per l'acqua piovana, che aumentano l'efficienza e riducono gli scarti senza sconvolgere l'integrità architettonica, e per di più diventano ancora più convenienti per l'uso a lungo termine.

Ecological Houses esplora 32 progetti residenziali da tutto il mondo, ciascuno con un suo perfetto equilibrio tra semplicità e tecnologia applicate alla sostenibilità e all'efficienza energetica. Gli architetti responsabili dei progetti presentati provengono dall'emergente cultura del gusto estetico ed ambientale orientato al futuro, e le loro idee riflettono i principi del design abitativo ecologico delle civiltà del passato. Le loro opere costituiscono un'elegante testimonianza dell'enorme potenziale dell'architettura ecologica, trasformando in meglio il nostro modo di vivere.

Sarah Rich

Solar House

Stuttgart I Germany

Architecture: (se)arch, Prof. Stefanie Eberding + Stephan Eberding Architekten BDA
Stuttgart, Germany
www.se-arch.de
Photos: Zooey Braun

Constructed with solid wood prefabricated panels, the Solar House obtains all of its power through solar collection tubes, with excess to spare. A 1000 liter tank stores extra energy to heat the home's floors and water system. The highly efficient building uses a scant 32 kWh/m² on average.

Das aus vorgefertigten Massivholzelementen konstruierte Solar House gewinnt seine gesamte Energie durch Sonnenkollektoren, deren Überschussproduktion gespeichert werden kann. Ein 1000 Liter Tank speichert diese zusätzliche Energie, um die Böden und das Wasserleitungssystem des Hauses zu beheizen. Dieses hocheffiziente Gebäude verbraucht somit im Schnitt knapp 32 kWh/m².

Construite en panneaux préfabriqués de bois massif, la Solar House obtient toute son énergie, dont l'excédent est stocké, au moyen de tubes solaires. Un réservoir de 1000 litres emmagasine l'énergie supplémentaire pour chauffer les sols et le réseau d'alimentation en eau de la maison. Cette maison très rationnelle consomme à peine 32 kWh/m² en moyenne.

Construida con paneles prefabricados de madera, la Solar House obtiene incluso más de la energía que necesita por medio de unos colectores solares en forma de tubo. Un tanque de 1.000 litros almacena la energía sobrante, que vierte en el sistema de calefacción de suelos y agua de la casa. El consumo medio de este eficiente inmueble es mínimo: 32 Kwh/m².

Costruita in pannelli prefabbricati in legno massiccio, la Solar House ricava tutta la propria energia da tubi solari, e ne avanza. Un serbatoio da 1000 litri immagazzina l'energia extra per il riscaldamento dei pavimenti e del sistema idraulico. Questo edificio ad alto rendimento usa appena 32 kWh/m² in media.

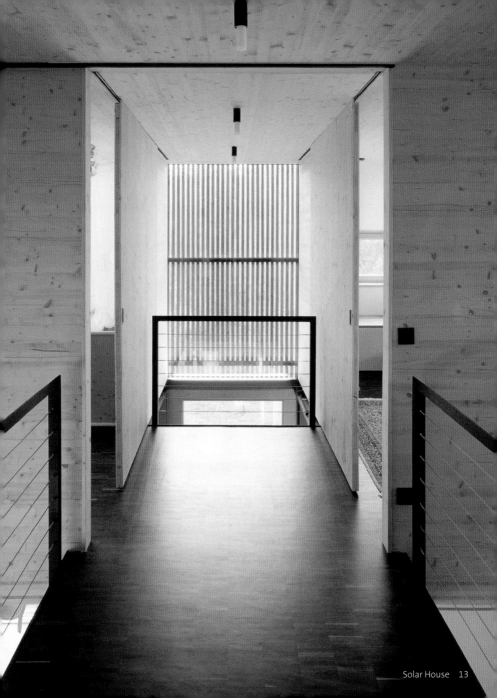

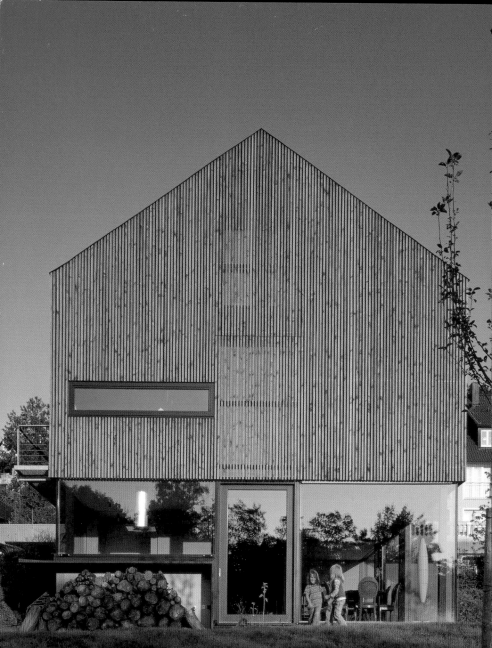

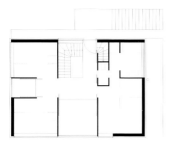

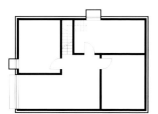

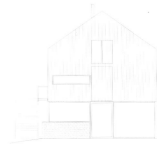

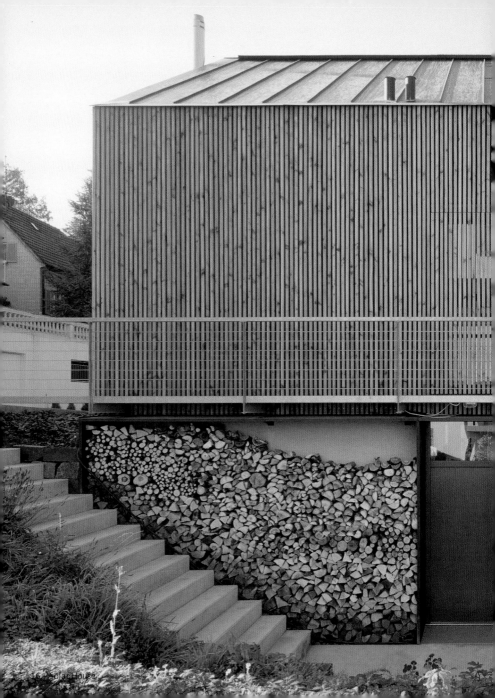

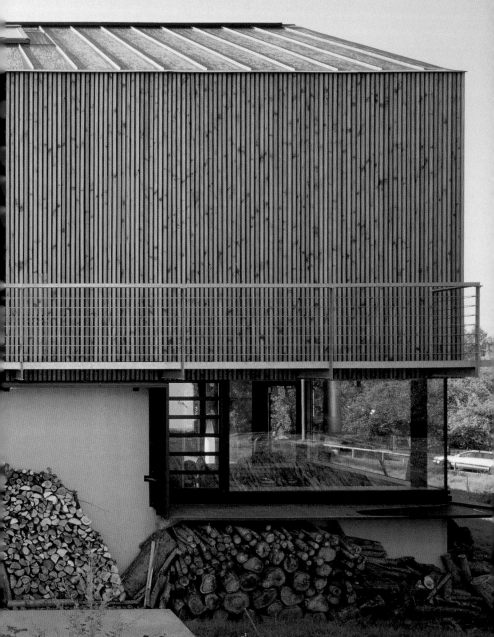

Walla Womba Guest House Bruny Island, Tasmania I Australia

Architecture: 1+2 Architecture
Hobart, Tasmania, Australia
www.1plus2architecture.com
Photos: 1+2 (pages 19, 20), Peter Hyatt (pages 22, 23)

The single-storey Walla Womba house is well equipped for independent living in the Australian bush. Using passive environmental design, solar power, rainwater collection, and greywater recycling, 1+2 Architecture built a tool kit for taking energy consumption and waste production down to zero.

Das eingeschossige Walla Womba Guest House ist für ein unabhängiges Leben im australischen Busch perfekt ausgestattet. Durch eine schonende, umweltfreundliche Planung, die Nutzung von Solarenergie, Regenwasser und Grauwasserrecycling konstruierte 1+2 Architecture ein Bauprinzip, mit dem der Energieverbrauch und die Abfallproduktion auf Null heruntergefahren werden konnte.

La Walla Womba Guest House, sur un seul niveau, est bien équipée pour une vie indépendante dans le bush d'Australie. En utilisant un design environnemental passif, l'énergie solaire, la collecte des eaux de pluie et le recyclage des eaux usées, 1+2 Architecture a construit une boîte à outils pour ramener à zéro la consommation d'énergie et la production de déchets.

La casa Walla Womba Guest House de una sola planta está perfectamente equipada para la vida independiente en el bosque australiano. Con un diseño pasivo, energía solar, recolección de aguas pluviales y reciclaje de aguas residuales, 1+2 Architecture han ideado un sistema de construcción capaz de reducir a cero el consumo de energía y la producción de desechos.

La casa ad un piano Walla Womba è bene attrezzata per una vita indipendente nel bush australiano. Con design ambientale passivo, energia solare, raccolta dell'acqua piovana e riciclaggio delle acque grigie, 1+2 Architecture ha creato uno strumento per azzerare i consumi energetici e la produzione di rifiuti.

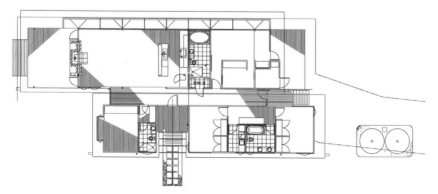

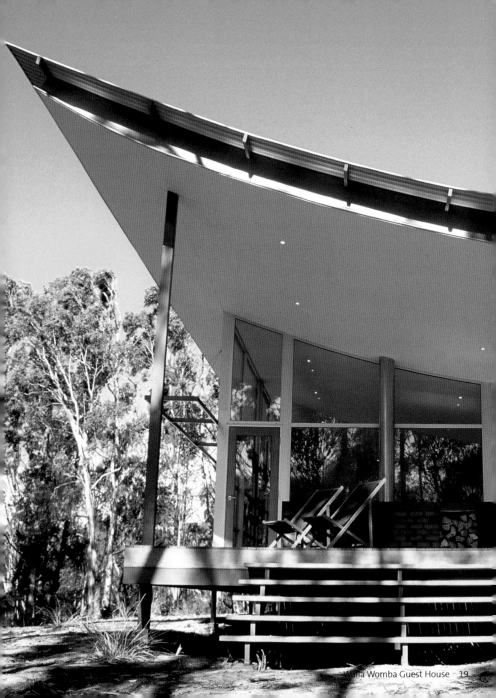

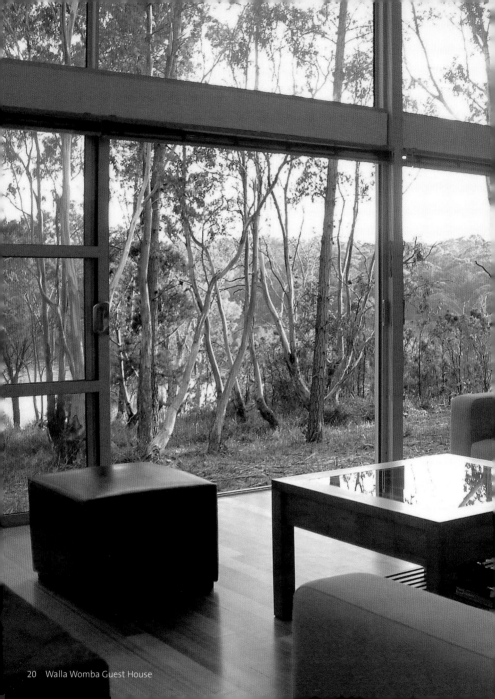

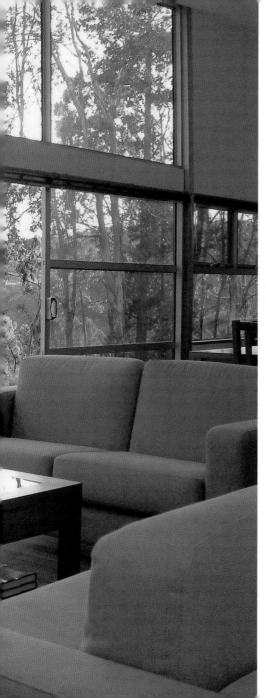

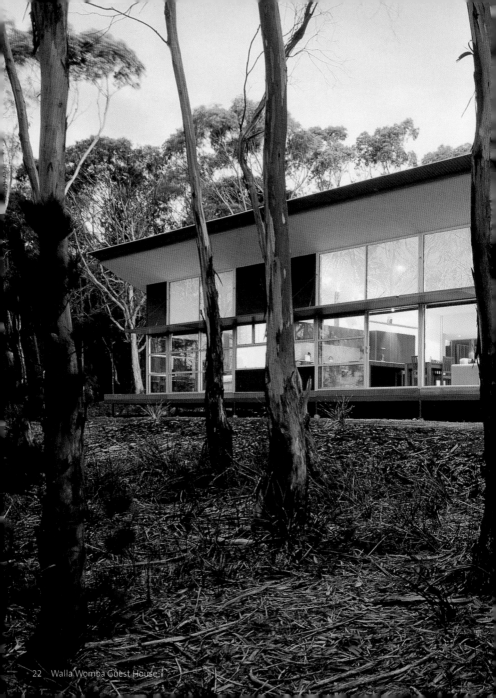

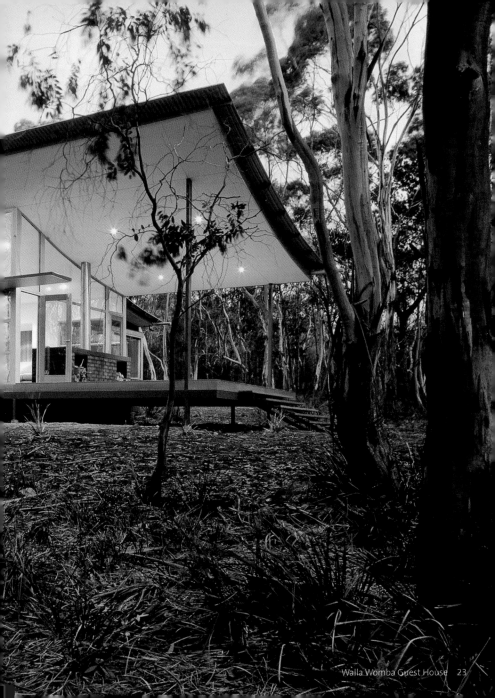

Essex St House

Brunswick, Victoria I Australia

Architecture: Andrew Maynard Architects
Melbourne, Victoria, Australia
www.andrewmaynard.com.au
Photos: Peter Bennetts (pages 25, 27, 29), Dan Mahon (page 28)

Using primarily salvaged and recycled wood, Andrew Maynard constructed large exterior screens that provide shade and allow daylight to filter inside. The floor-to-ceiling windows lift up, opening the entire house to the outdoors. These passive construction strategies are both elegant and efficient.

Unter vorrangiger Verwendung von recyceltem Holz und solchem schnell nachwachsender Arten konstruierte Andrew Maynard an der Fassade großzügige, Schatten spendende Blenden, durch die das Tageslicht angenehm gefiltert nach innen dringt. Die vom Boden zur Decke reichenden Fenster strecken den Bau optisch und scheinen das gesamte Haus nach außen zu öffnen. Diese passive Bauweise ist sowohl elegant als auch energieeffizient.

Avec, pour l'essentiel, du bois de récupération et recyclé, Andrew Maynard a construit de grands écrans extérieurs qui procurent de l'ombre et permettent à la lumière du jour de filtrer à l'intérieur. Les baies vitrées se relèvent, ouvrant entièrement la maison sur l'extérieur. Ces stratégies de construction passives sont à la fois élégantes et économes.

Empleando fundamentalmente madera reciclada y ecológica, Andrew Maynard construyó grandes pantallas exteriores que proporcionan sombra y filtran la luz diurna. Las cristaleras suelo-techo realzan y abren la vivienda al exterior. Estos métodos de construcción pasiva resultan elegantes y eficientes a la vez.

Con prevalenza di legno recuperato e riciclato, Andrew Maynard ha creato ampie pareti esterne che forniscono ombra e lasciano trapelare la luce del giorno. Le finestre a sollevamento, alte fino al soffitto, aprono l'intera abitazione verso l'esterno. Queste strategie di costruzione passiva sono insieme eleganti ed efficienti.

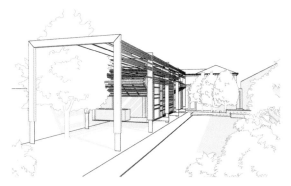

24 Essex St House

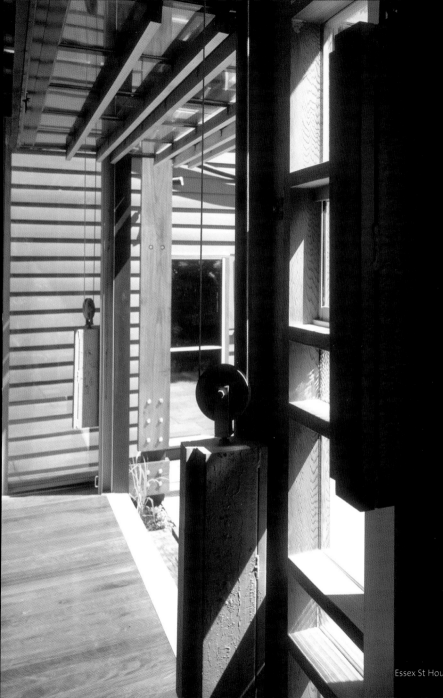
Essex St Hou

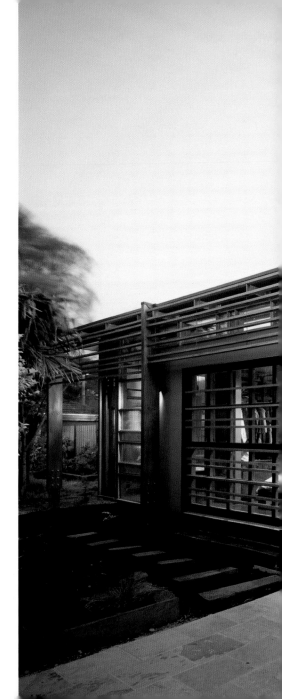

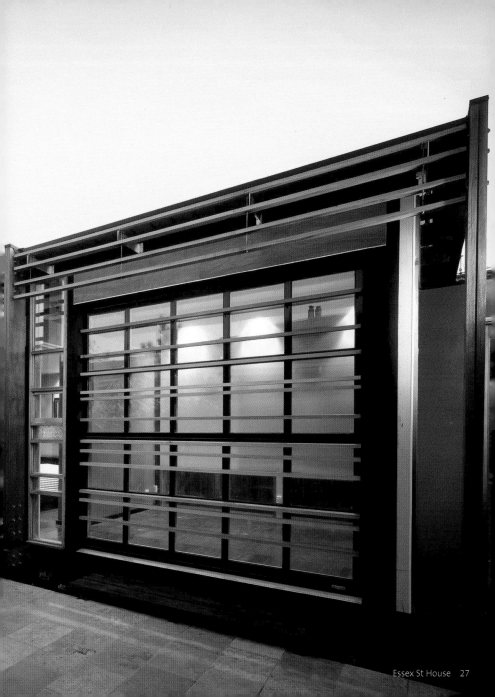

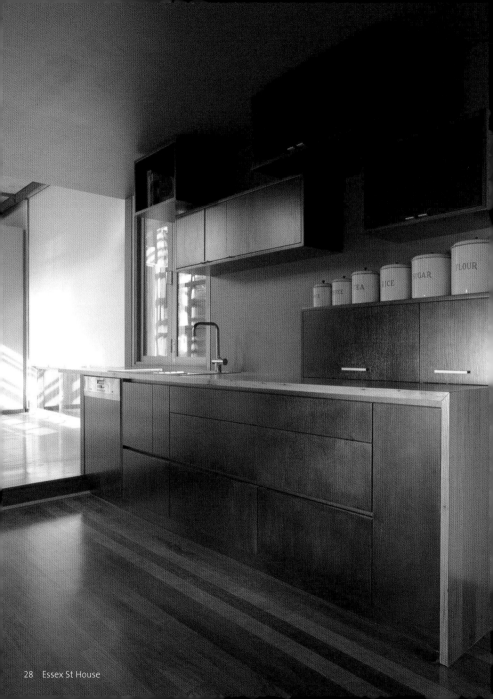

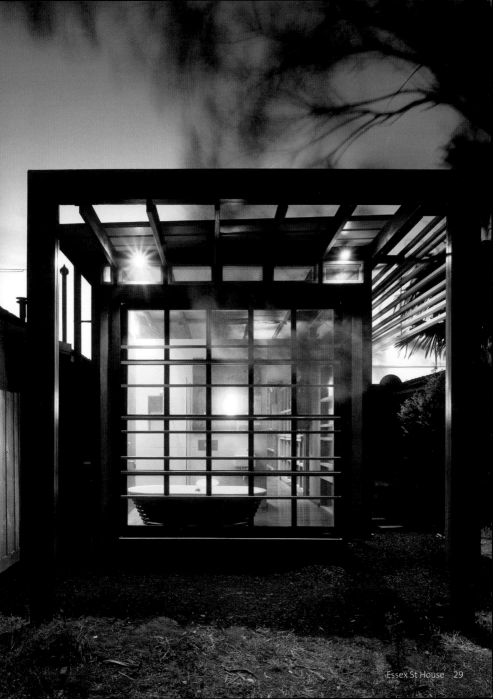

House in the Schurwald

Architecture: Architektin TV: Dr. Tina Volz, Michael Resch; Energy Specialist Dr. Thomas Stark
Stuttgart, Langenargen, Germany
www.architektin-tv.de
Photos: Andreas Keller

Under a 66-panel solar canopy, concrete walls act as insulators as well as thermal slabs that retain and radiate heat. The photovoltaic roof produces energy that runs directly into Schurwald's public grid and returns back to the house in the form of credits, meeting all of the home's energy demands.

Unter einer Bedachung aus 66 Sonnenkollektoren fungieren Betonwände als Isolatoren sowie als Thermoplatten, welche sowohl die Wärme speichern als auch wieder abgeben. Das photovoltaische Dach erzeugt Energie, die direkt in das öffentliche Stromnetz von Schurwald eingespeist wird, und in Form von Gutschriften zurückfließt, die den gesamten Energiebedarf des Hauses decken.

Sous une canopée de 66 panneaux solaires, les murs de béton font fonction à la fois d'isolants et de dalles thermiques qui retiennent et diffusent la chaleur. Le toit photovoltaïque produit de l'énergie qui entre directement dans le réseau public de Schurwald et revient dans la maison sous forme de crédits couvrant tous les besoins en énergie de la maison.

Bajo una cubierta de 66 placas solares, las paredes de hormigón actúan de aislante o a modo de losas térmicas que retienen y despiden el calor. La energía producida por el tejado fotovoltaico se transfiere a la red pública de Schurwald y revierte a la casa en forma de créditos que cubren todas las necesidades energéticas de la vivienda.

Sotto una tettoia di 66 pannelli solari, i muri in cemento fungono da isolanti e da piastre termiche, trattenendo e irradiando calore. La copertura fotovoltaica fornisce energia che fluisce direttamente nella rete pubblica di Schurwald, per poi tornare alla casa in forma di crediti, soddisfacendo tutti i suoi bisogni energetici.

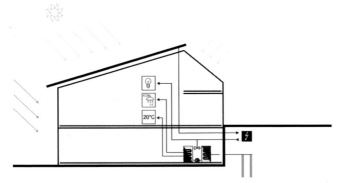

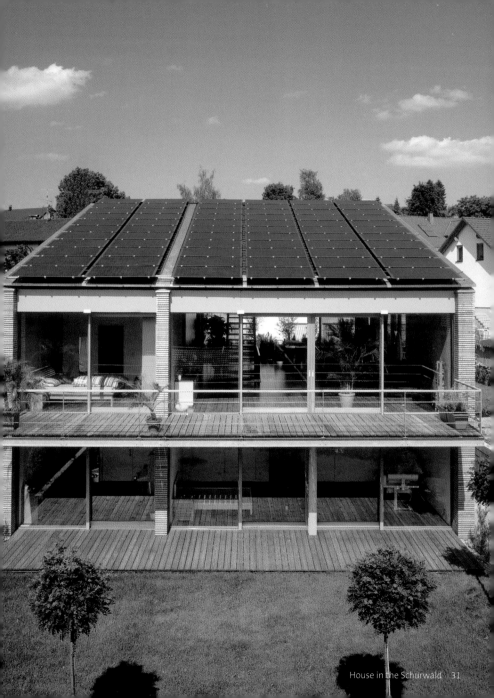

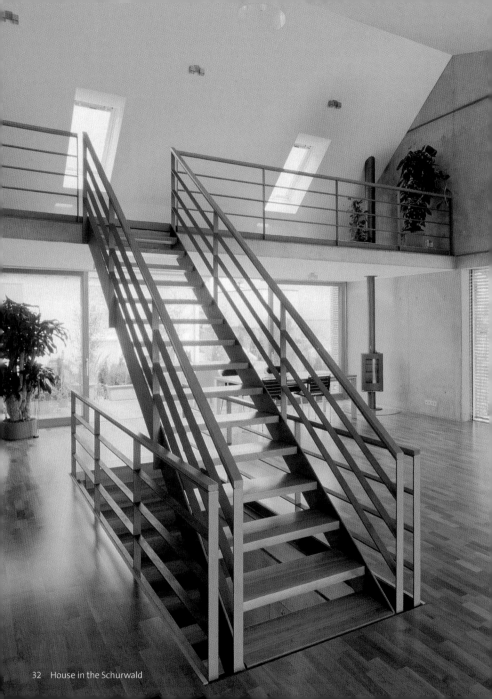

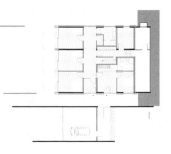

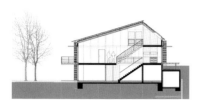

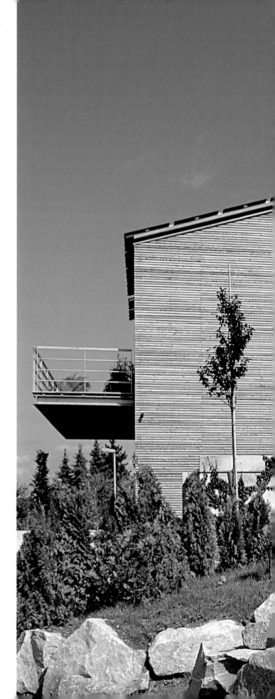

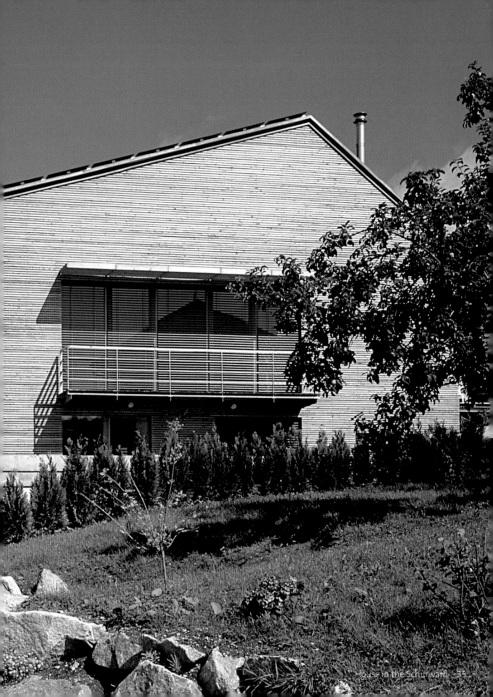

Gully House

Yeronga, Queensland I Australia

Architecture: Bligh Voller Nield
Brisbane, Australia
www.bvn.com.au
Photos: David Sandison

The Gully House is situated naturally among large trees and foliage, above the banks of the Brisbane River. The structure is elevated on steel supports to avoid disrupting overland river flow and tree root systems. With the future in mind, the architects selected materials that could be disassembled and recycled.

Das Gully House liegt in seine natürliche Umgebung eingebettet zwischen hohen Bäumen oberhalb des Ufers des Brisbane Flusses. Der Bau lagert erhöht auf Stahlträgern, um Schäden zu vermeiden, die durch Überflutungen und Wurzelwerk entstehen können. Im Hinblick auf die Zukunft wählten die Architekten demontierbare Elemente und recycelbare Materialien für ihre Konstruktion.

La Gully House est située en pleine nature parmi les grands arbres et les frondaisons, au-dessus des berges de la Brisbane. La structure, surélevée, repose sur des supports d'acier pour permettre au ruissellement de surface de continuer vers la rivière et préserver le système radiculaire des arbres. En pensant à l'avenir, les architectes ont choisi des matériaux qui peuvent être désassemblés et recyclés.

La Gully House está inmersa en plena naturaleza, entre inmensos árboles y un espeso follaje junto a la ribera de río Brisbane. La estructura se eleva sobre unos soportes de acero con el fin de evitar los posibles daños provocados por las crecidas del río o las raíces arbóreas. Con auténtica visión de futuro, los arquitectos seleccionaron materiales fáciles de desmontar y reciclar.

La Gully House è naturalmente situata tra grandi alberi e vegetazione rigogliosa, sulle sponde del Brisbane River. La struttura poggia su supporti d'acciaio per non disturbare il deflusso del fiume e le radici degli alberi. Pensando al futuro, gli architetti hanno selezionato materiali smontabili e riciclabili.

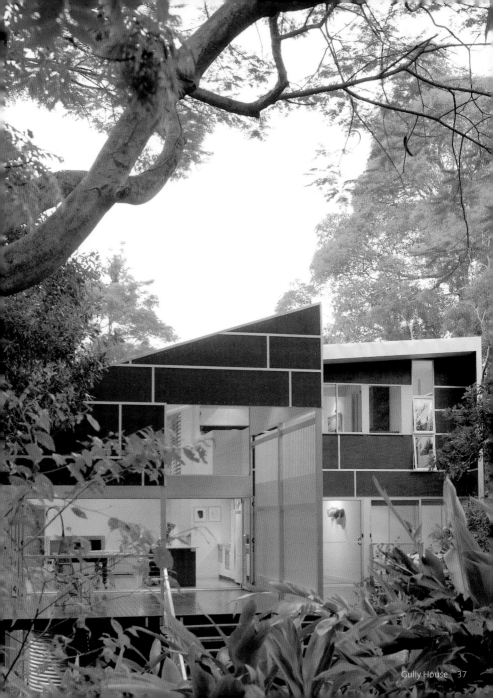

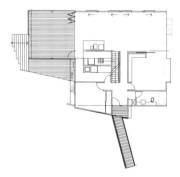

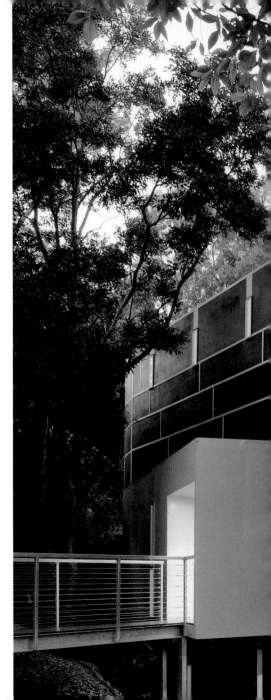

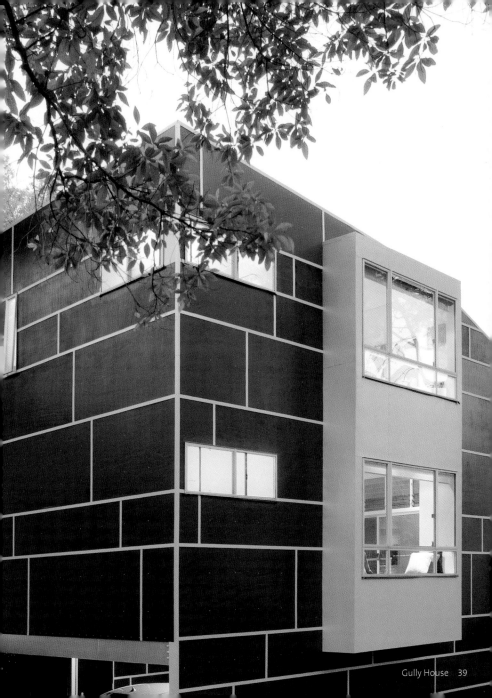

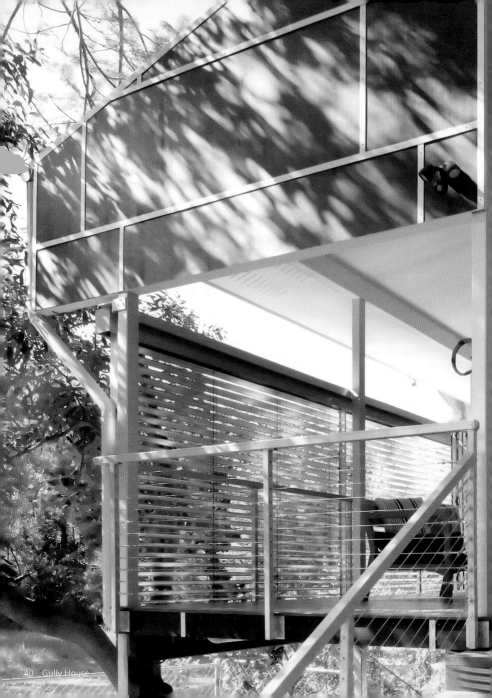

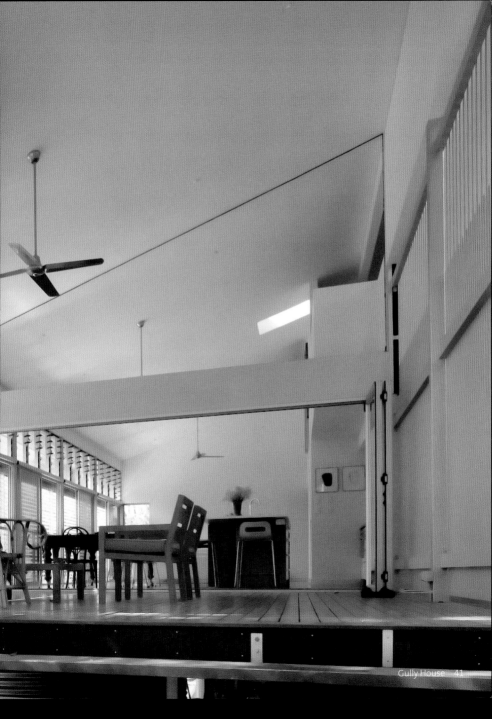

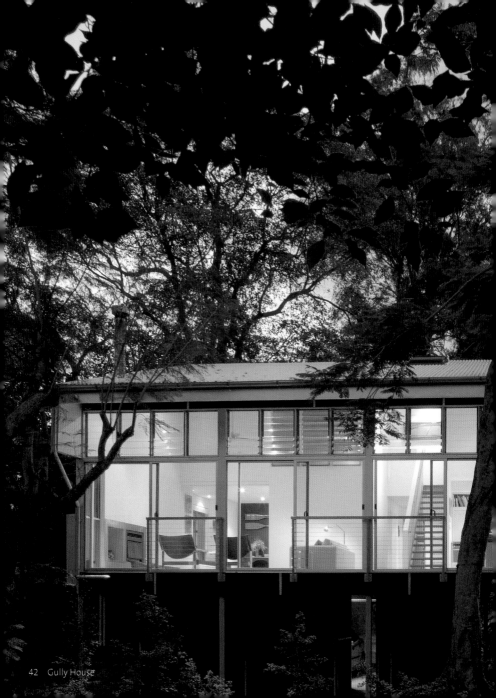

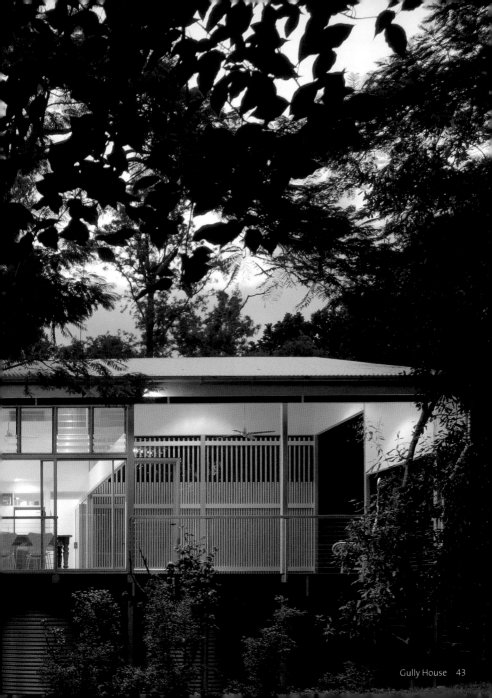

T-Bone House

Waiblingen I Germany

Architecture: COAST GbR – Zlatko Antolovic, Alexander Wendlik
Stuttgart, Germany
www.coastoffice.de
Photos: David Franck

Blurring the boundaries between indoor and out, the T-Bone House opens with a sliding glass façade and the slate floor runs out to the garden. To accommodate the seasons and reduce energy needs, the house has a geothermal heat pump with a vertical ground loop that both heats and cools the living spaces.

Ein durchgängiger Schieferboden im Wohn- und Terrassenbereich sowie eine sich zum Garten hin öffnende Glasschiebefront lassen den Innen- und Außenbereich fließend ineinander übergehen. Um den Energiebedarf zu reduzieren und zur Berücksichtigung der jahreszeitlichen Temperaturen, besitzt das Haus eine geothermische Wärmepumpe mit einer vertikalen Erdschleife, die zum Heizen und Kühlen der Wohnräume dient.

Estompant la limite entre intérieur et extérieur, la maison T-Bone s'ouvre grâce à une façade de verre coulissante et le sol en ardoise se prolonge dans le jardin. Pour être en harmonie avec les saisons et réduire les besoins en énergie, la maison dispose d'une pompe à chaleur géothermique avec une boucle verticale en profondeur afin de chauffer et de rafraîchir les espaces de vie.

Los límites entre el espacio interior y exterior se difuminan en la casa T-Bone a través del pavimento de pizarra en el salón y la terraza y el frontal de cristaleras corredizas prolongados hasta el jardín. Para adaptarse a las estaciones del año y ahorrar energía, la vivienda cuenta con una bomba de calor geotérmica vertical con bucle de conexión a tierra que calienta y refrigera las estancias.

Confondendo la frontiera tra interno ed esterno, la T-Bone House si apre con una facciata in vetro scorrevole, e il pavimento in ardesia arriva fino in giardino. Per adattarsi alle stagioni e ridurre i fabbisogni energetici, è provvista di una pompa di calore geotermica con un pozzo verticale, in grado di riscaldare o rinfrescare gli spazi abitativi.

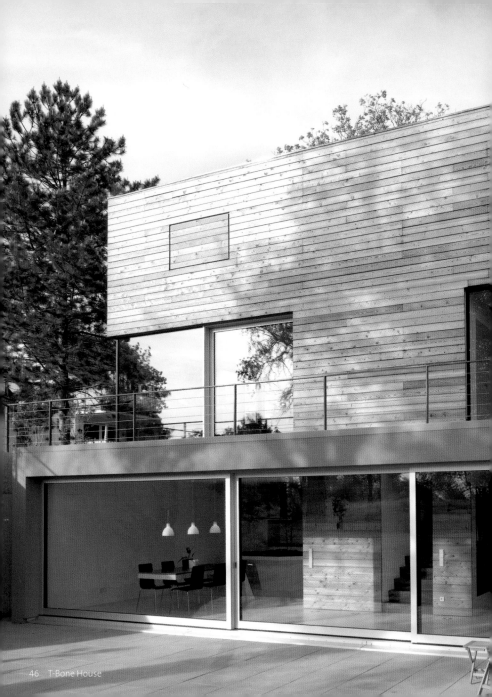

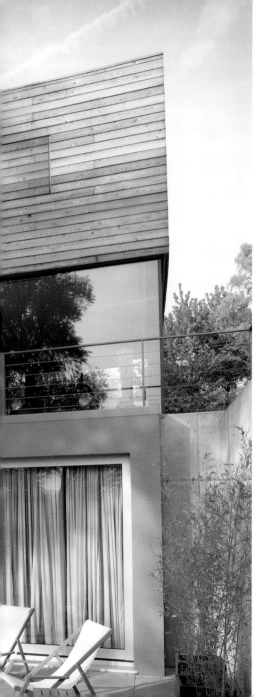

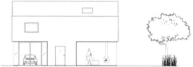

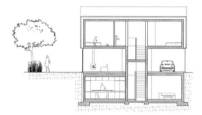

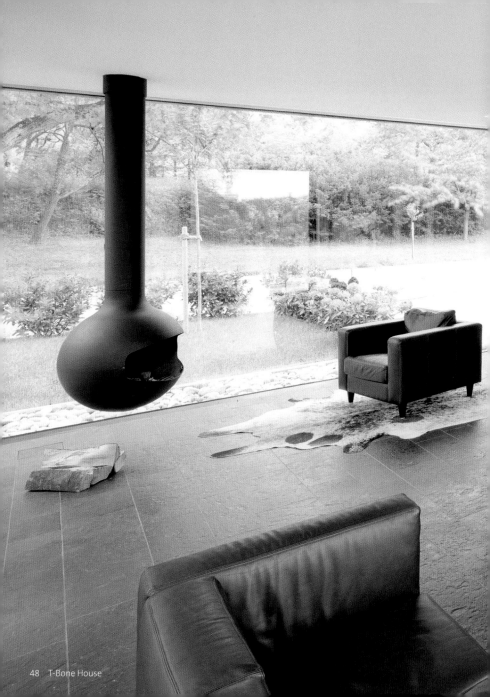

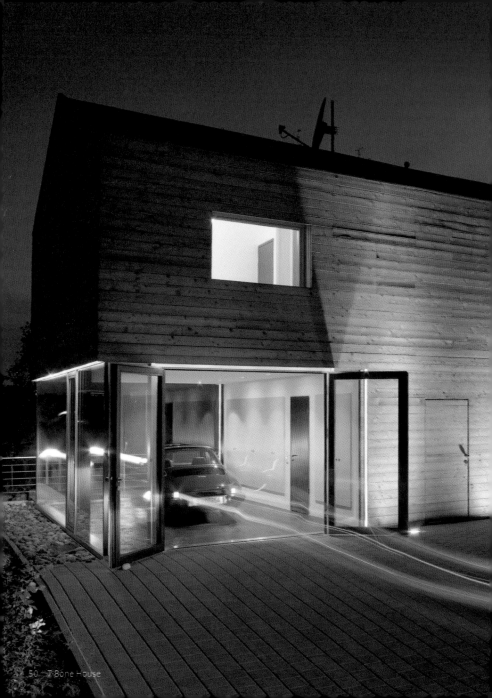

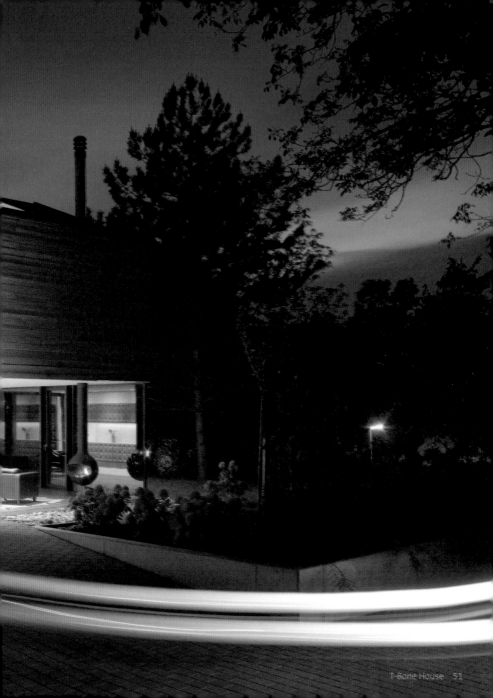

Barerock

Drag Lake, Ontario I Canada

Architecture: Dan & Diane Molenaar
Toronto, Ontario, Canada
www.mafcohouse.com
Photos: Christopher Wadsworth (page 53), Joseph Franke (pages 54, 55, 56, 57)

Nestled in the woods of Ontario, Barerock camouflages with its surroundings. The fir post-and-beam construction, wood-burning stoves and wide plank ceilings give it the character of a cabin, while solar power, on-demand water heating and abundant light make it a proud member of the modern green club.

Eingebettet in die Wälder Ontarios, fügt sich Barerock perfekt in seine Umgebung ein. Die aus Tannenholzpfosten und -balken bestehende Konstruktion, Holzöfen und großzügige Holzdecken verleihen dem Haus einen gewissen Hüttencharakter. Durch die Nutzung von Sonnenenergie, einer bedarfsgerechten Warmwasseranlage sowie üppigen Lichteinfall zählt dieses Haus zu den besten Beispielen modernen Ökohausbaus.

Nichée dans les bois de l'Ontario, Barerock se fond avec son environnement. Sa structure en poutres et poteaux de sapin, ses poêles à bois et ses plafonds en lambris lui donnent l'aspect d'une cabane ; son énergie solaire, son eau chaude à la demande et sa lumière abondante font de cette maison un membre exemplaire du club moderne des maisons écologiques.

Ubicada en los bosques de Ontario, Barerock se camufla en el entorno. La construcción con postes y vigas de abeto, las chimeneas de leña y los techos blancos de tablones le confieren un aspecto de cabaña, mientras que la energía solar, el agua caliente a voluntad y la abundante luz natural la convierten en un magistral ejemplo de construcción de vivienda ecológica.

Annidata nei boschi dell'Ontario, Barerock si mimetizza nell'ambiente. Per la sua costruzione squadrata in abete, le stufe a legna e i soffitti ad ampie tavole, ricorda una baita, mentre per l'energia solare, il riscaldamento dell'acqua su richiesta e l'abbondanza di luce rientra a pieno diritto nel moderno "club verde".

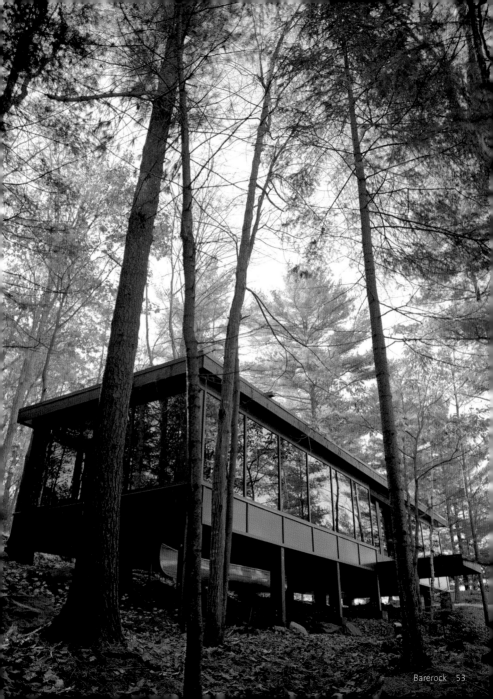

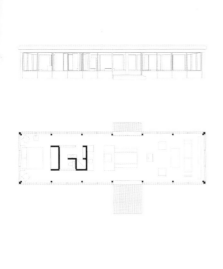

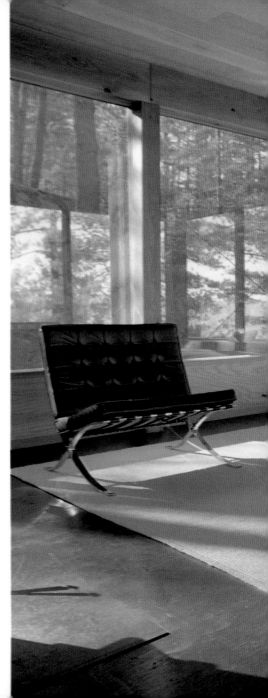

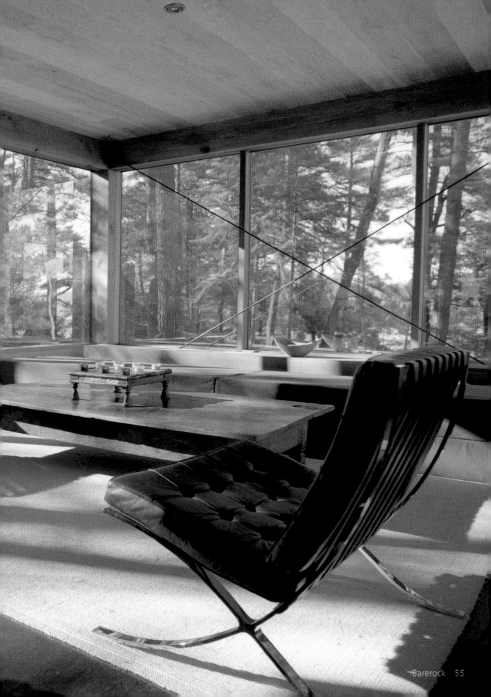

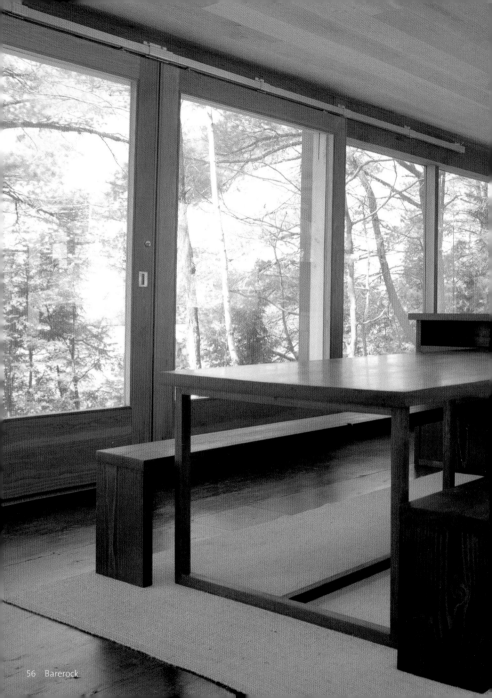

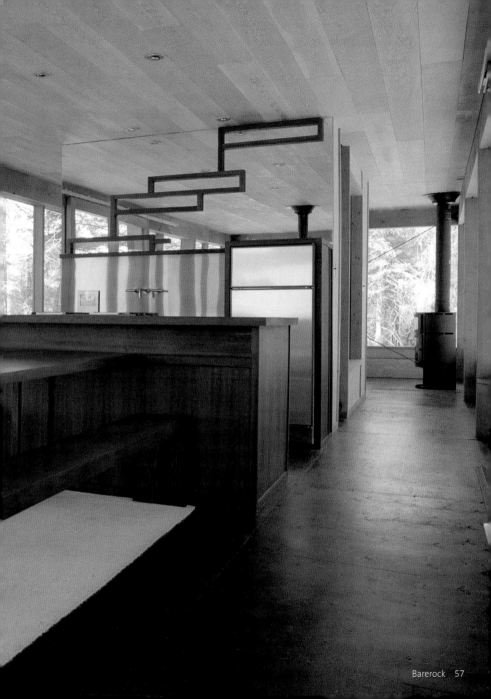

Villa Bio

Architecture: Cloud 9, Enric Ruiz-Geli
Barcelona, Spain
www.ruiz-geli.com
Photos: enric ruiz-geli © cloud9, www.e-cloud9.com

The Villa Bio is as much biological art as it is residential architecture. Designed first as a three-dimensional topographical model, the building itself mirrors the lines of the land. On the flat concrete rooftop, greenery grows in a spiral that flows naturally into the surrounding grass hillside.

Die Villa Bio ist biologisches Kunstwerk und Wohnarchitektur in einem. Ursprünglich als ein dreidimensionales, topographisches Modell geplant, spiegelt das Gebäude die Silhouette der Umgebung wider. Auf dem flachen Betondach ist die Begrünung spiralförmig angelegt, um schließlich in den umliegenden natürlichen Grashang überzugehen.

La Villa Bio est tout autant une œuvre d'art biologique qu'une architecture résidentielle. Conçu d'abord comme un modèle topographique tridimensionnel, le bâtiment en lui-même reflète les lignes du paysage. Sur le toit plat en béton, la verdure pousse dans une spirale qui se fond naturellement avec les collines herbeuses environnantes.

Villa Bio es tanto arte biológico como arquitectura residencial. Diseñada en un primer momento como modelo topográfico tridimensional a escala, la propia casa refleja las líneas del entorno. Sobre el tejado de hormigón crece la vegetación formando una espiral que se funde de manera natural con la loma de hierba que lo circunda.

La Villa Bio appartiene all'arte biologica quanto all'architettura residenziale. Concepito inizialmente come modello topografico tridimensionale, l'edificio stesso rispecchia i tratti della terra. Sul piatto tetto in cemento, il fogliame cresce in spirali che fluiscono spontaneamente verso le colline erbose circostanti.

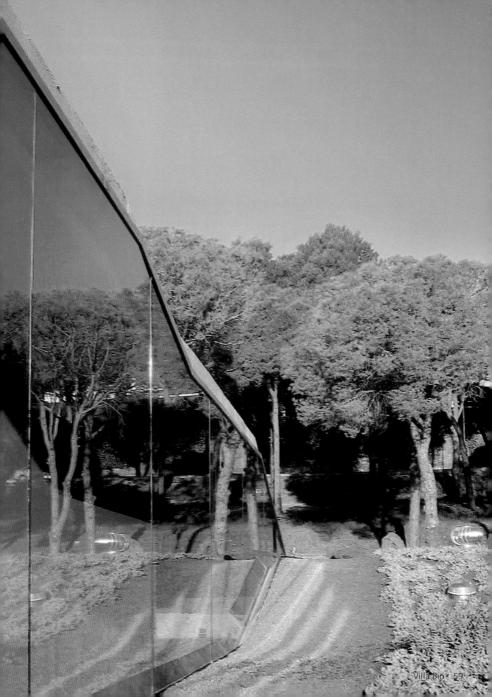

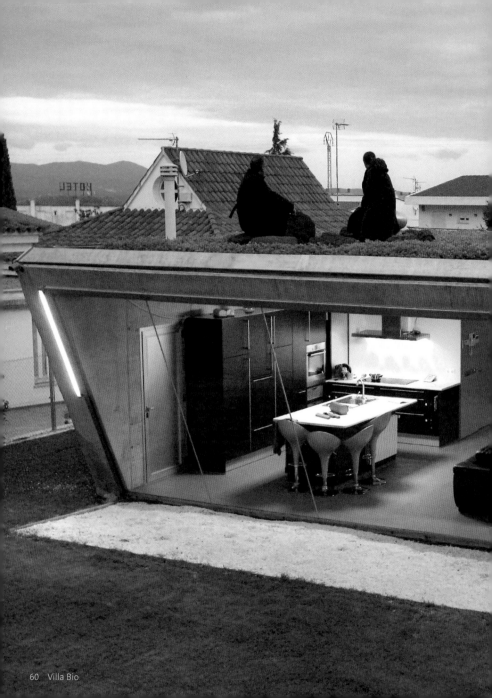

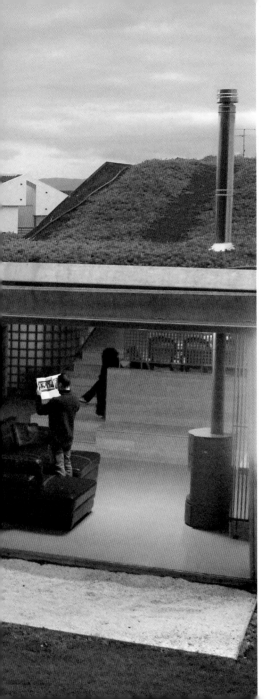

Wall House

Architecture: **FAR** frohn&rojas
Köln / Germany, Santiago de Chile, Ciudad de México
www.f-a-r.net
Photos: Cristobal Palma

The Wall House was built in four concentric layers to create four different living environments, from the cave-like concrete interior to the soft fabric exterior skin. The radiant concrete, operable, full-height glazed windows, and double exterior tent of woven textiles create a flexible and low-energy home.

Das Wall House wurde in vier konzentrischen Schichten gebaut, um vier unterschiedliche Lebensräume zu schaffen – vom höhlenartigen Interieur aus Beton bis hin zur weichen, aus Gewebe bestehenden Außenhaut. Der glänzende Beton, bewegliche, verglaste Fenster, die über die gesamte Höhe reichen, und ein doppeltes Außenzelt aus gewebten Stoffen schaffen ein flexibles Niedrigenergiehaus.

La Wall House est construite en quatre couches concentriques pour créer quatre environnements de vie différents, de l'intérieur style cave en béton à l'extérieur avec son enveloppe textile souple. Le béton luisant, les baies vitrées pratiques et la double tente extérieure en textile tissé créent une maison flexible et économe en énergie.

La estructura de la Wall House consta de cuatro capas concéntricas que generan cuatro ambientes diferentes, desde el interior de hormigón semejante a una cueva hasta el recubrimiento exterior de tejido ligero. El hormigón térmico, los ventanales abatibles de cuerpo entero y la carpa exterior textil conforman una vivienda flexible y de bajo consumo.

La Wall House è stata costruita in quattro strati concentrici e altrettanti ambienti vitali diversi, dall'interno "cavernoso" in cemento alla morbida buccia esterna in tessuto. Le pratiche e radiose finestre in cemento, con vetri alti fino al soffitto, e la doppia tenda esterna a tessuti intrecciati creano un'abitazione flessibile e a bassa energia.

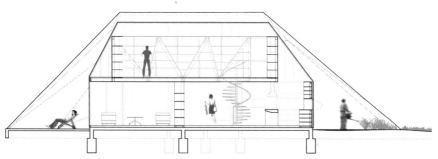

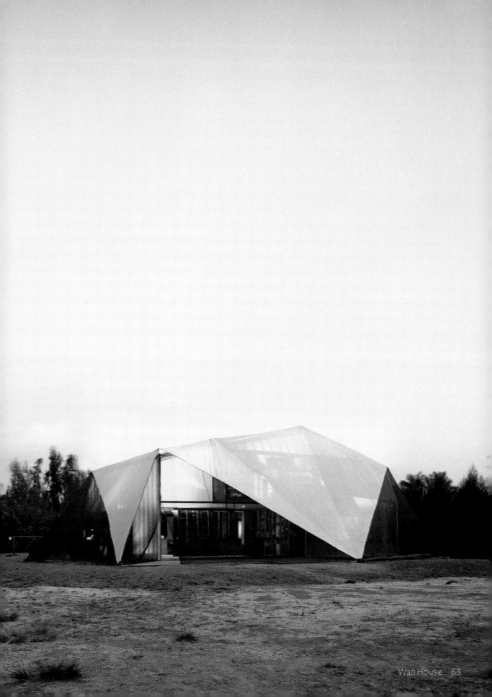

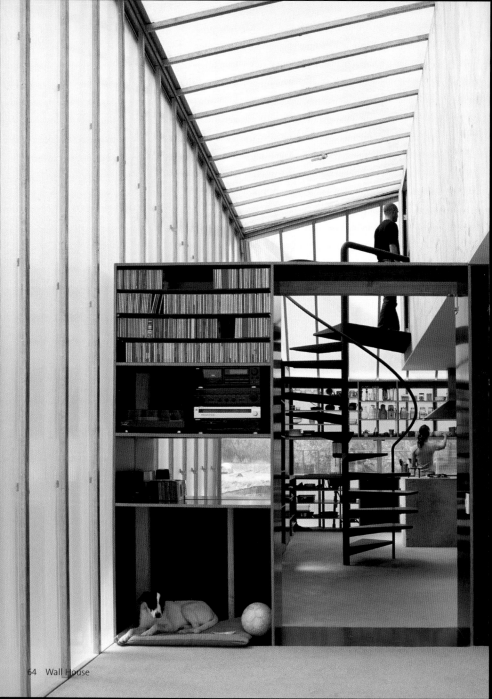

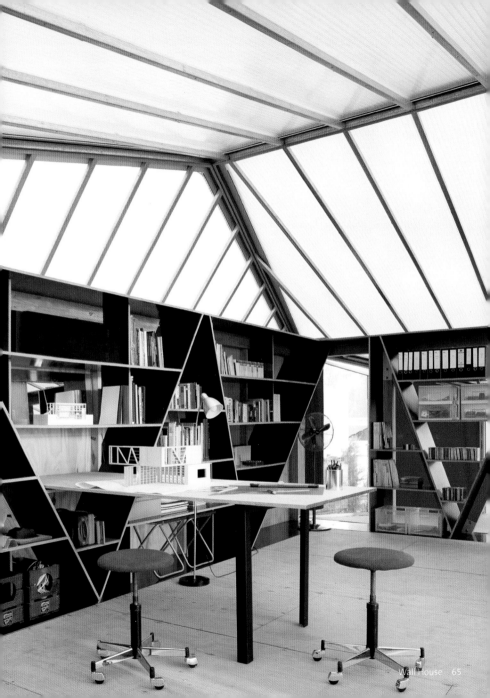

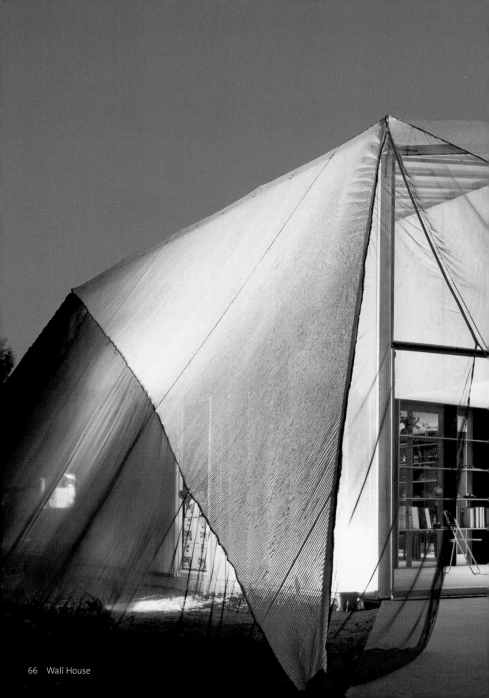

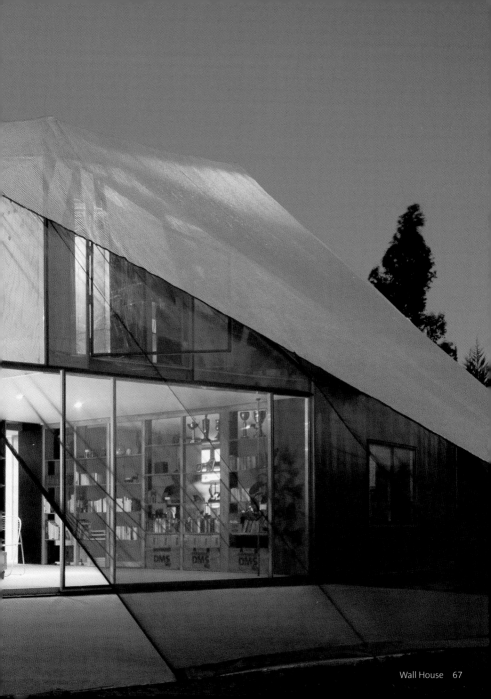

G+S House

Architecture: GATERMANN + SCHOSSIG
Köln, Germany
www.gatermann-schossig.de
Photos: Jens Willebrand (page 72), Robertino Nikolic (pages 69, 70, 73)

Taking partial advantage of a 1950s foundation wall, G+S House matches its neighbors in front with a white plaster façade, but on the back diverges completely from tradition with walls of aluminum and glass. An integrated rooftop solar array and rainwater storage system make the home largely self-sufficient.

Weil es in Teilen von einer Grundmauer aus dem Jahre 1950 profitiert, passt das G+S House mit seiner weiß verputzten Fassade von vorne gut zu den Häusern der Nachbarschaft. Betrachtet man es jedoch von hinten, weicht es durch seine Wände aus Aluminium und Glas komplett von traditionellen Bauweisen ab. Im Dach integrierte Solarzellen und ein Regenwasserauffang- und Bevorratungssystem machen das Haus weitgehend unabhängig.

En exploitant partiellement un mur de fondation de 1950, la maison G+S s'harmonise, sur le devant, avec ses voisines grâce à sa façade de crépi blanc, mais s'écarte totalement de la tradition, à l'arrière, avec des murs d'aluminium et de verre. Un générateur photovoltaïque intégré au toit et un système de stockage des eaux de pluie rendent la maison largement autosuffisante.

Aprovechando de forma parcial los cimientos de una construcción de los años 50, la G+S House se ha adaptado a las del vecindario con una fachada enlucida de blanco, mientras que la parte trasera se aleja totalmente de la tradición y opta por paredes de aluminio y vidrio. Las placas solares y el sistema de almacenamiento de agua pluvial consiguen que la vivienda se autoabastezca casi por completo.

Approfittando in parte di un muro portante degli anni '50, la facciata in intonaco bianco della G+S House si confonde con i vicini, per poi distinguersi completamente all'interno, con pareti in vetro e alluminio. Una griglia solare integrata nel tetto e un sistema di conservazione dell'acqua piovana rendono la casa ampiamente autosufficiente.

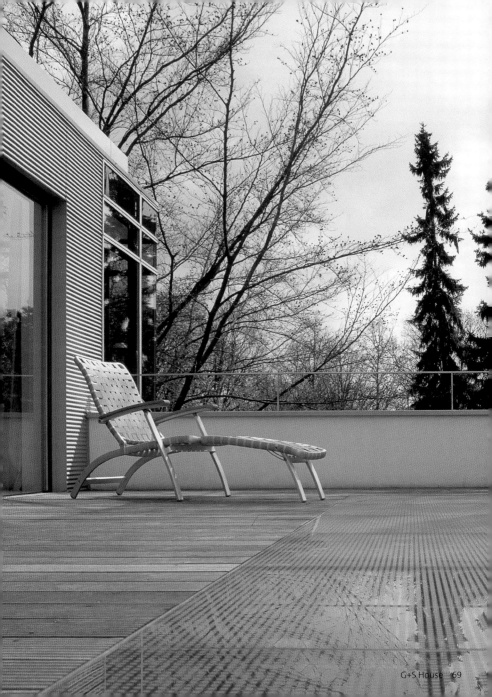

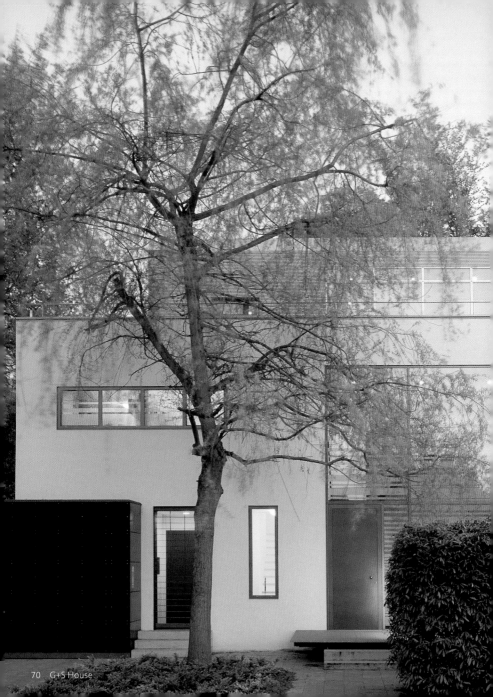

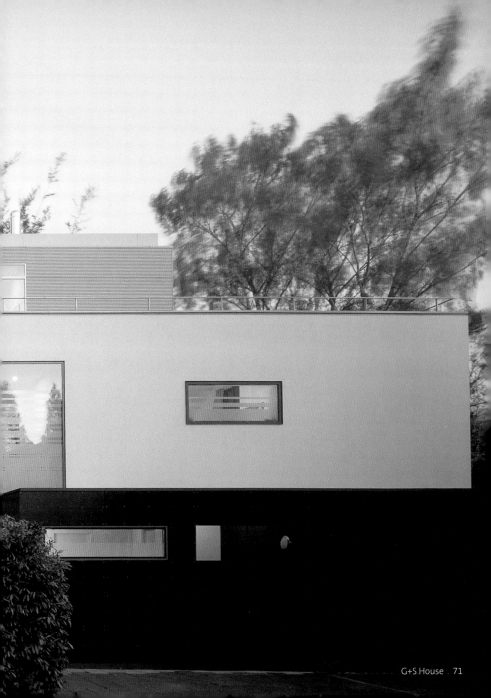

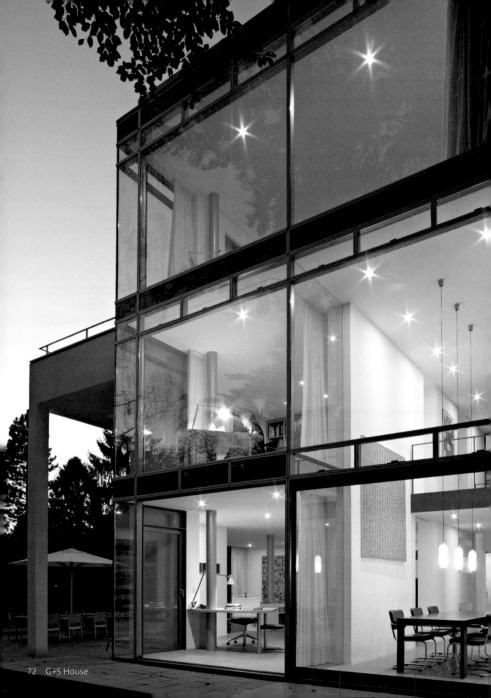

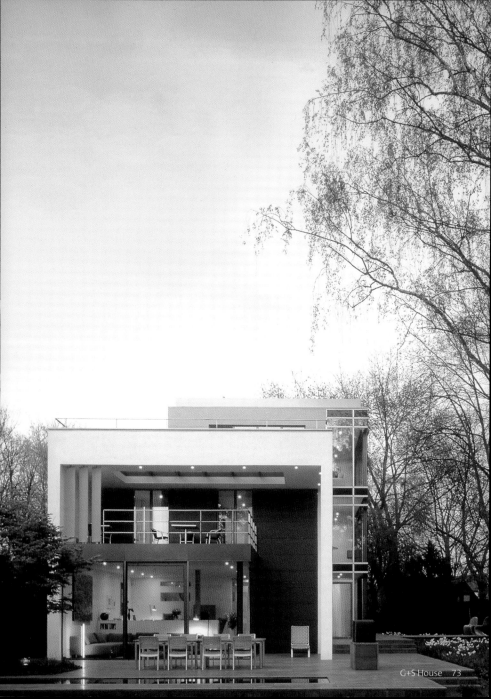

Solar Tube

Architecture: driendl*architects
Vienna, Austria
www.driendl.at
Photos: Bruno Klomfar (pages 75, 76, 79), James Morris (page 78)

Whereas some homes have solar tubes on the roof, this house is a solar collector unto itself. A central, 3-story atrium functions as a ventilation shaft and natural method of climate control. Towering higher than the atrium, a grove of trees provides additional shade, insulation and filtered sunlight.

Während einige Eigenheime Solarzellen auf dem Dach haben, ist dieses Haus selbst durch und durch ein Sonnenkollektor. Ein zentrales, 3-geschossiges Atrium fungiert als Lüftungsschacht und bietet somit eine natürliche Möglichkeit zur Klimakontrolle. Eine über das Atrium hinausragende Baumgruppe spendet zusätzlichen Schatten, Dämmung und gefiltertes Sonnenlicht.

Alors que certaines maisons possèdent des tubes solaires sur le toit, cette maison est un collecteur solaire en elle-même. Un atrium central sur 3 niveaux fonctionne comme puits de ventilation et constitue une méthode naturelle de conditionnement d'air. Dominant l'atrium, un bosquet vient offrir ombre, isolation et lumière filtrée.

Hay viviendas que cuentan con colectores solares en el tejado; sin embargo, esta casa es un colector en sí misma. Un atrio central de 3 plantas ejerce de chimenea de ventilación y sistema natural de control de la temperatura. Por encima del atrio, una arboleda proporciona sombra adicional, aislamiento térmico y filtra la luz solar.

Se alcune abitazioni hanno tubi solari sul tetto, questa è un intero collettore solare. Un atrio centrale a 3 piani funge da canna di ventilazione e da metodo naturale di climatizzazione. Sovrastando l'atrio, un boschetto alberato fornisce ulteriore ombra, isolamento e luce solare attutita.

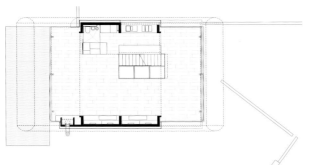

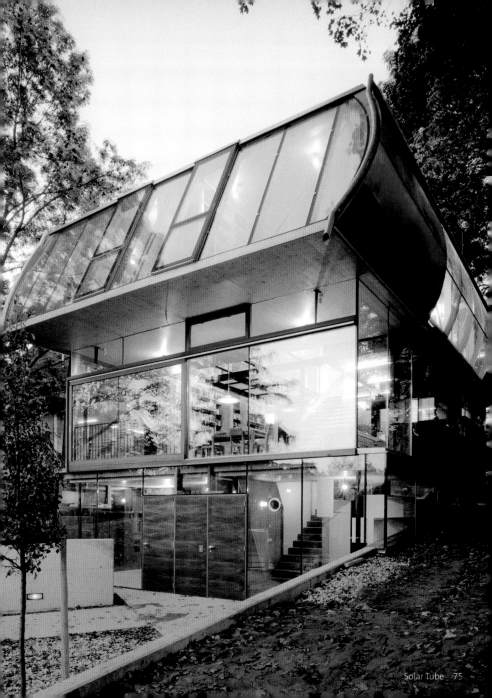

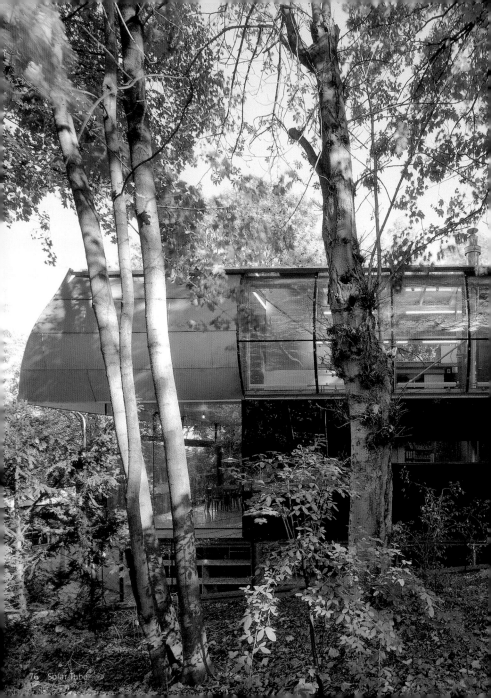

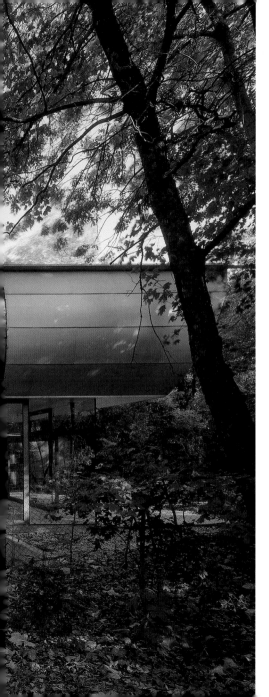

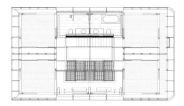

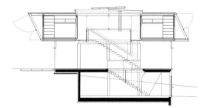

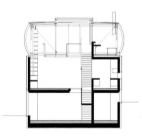

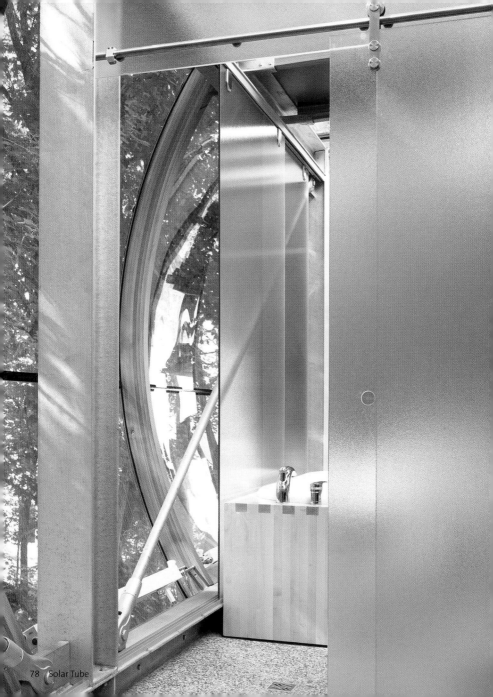

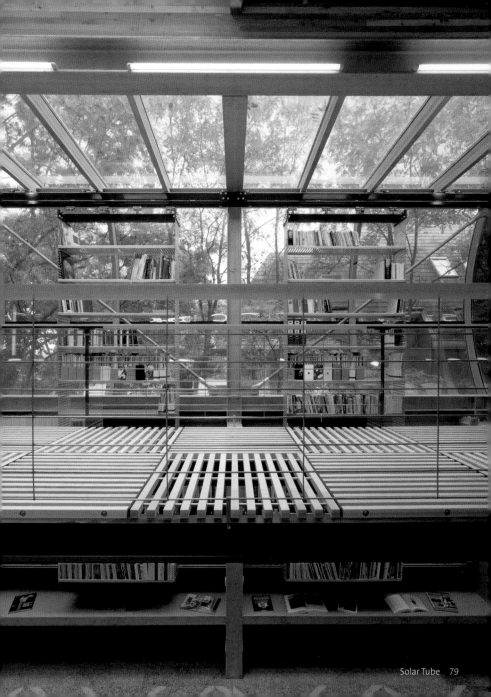

Kropach Catlow House

Yocum I Australia

Architecture: Grose Bradley — James Grose, Walter Carniato
Sydney, Australia
www.grosebradley.com
Photos: Peter Hyatt

Though nothing like a traditional farmhouse, this home's simplicity and connection to the land invoke the prairie, with sliding windows and walls that integrate the natural surroundings and create cross breezes. The mobile, prefab structure can be disassembled, and its steel and glass components recycled.

Obwohl alles andere als ein traditionelles Bauernhaus, beschwören die Einfachheit und Verbindung mit dem umliegenden Land durch Schiebefenster und -wände, welche die natürliche Umgebung einbeziehen und für gute Lüftung sorgen, den Eindruck der Prärie herauf. Die mobile Fertighauskonstruktion ist demontierbar und aus recycelbaren Stahl- und Glaselementen.

Bien que ne ressemblant en rien à une ferme traditionnelle, la simplicité et l'ancrage de cette maison dans la terre sont un hommage à la prairie, avec ses fenêtres et ses murs coulissants, intégrant le cadre naturel et assurant une parfaite ventilation. La structure mobile préfabriquée peut être démontée et ses composants d'acier et de verre recyclés.

Si bien no se asemeja en nada a una granja, la simplicidad de esta construcción y sus vínculos con el campo evocan la pradera. Los ventanales corredizos y la tabiquería se integran en el entorno natural y generan brisas. La estructura prefabricada se puede desmontar y los componentes de acero y vidrio son reciclables.

Pur non assomigliando per nulla ad una fattoria, la semplicità e la connessione alla terra di questa casa evocano la prateria, con porte scorrevoli e pareti che integrano gli ambienti circostanti e creano correnti d'aria vaganti. La struttura mobile e prefabbricata è smontabile, con componenti in vetro e acciaio riciclate.

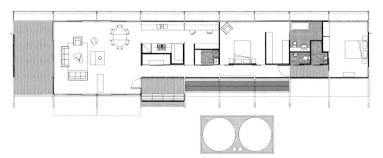

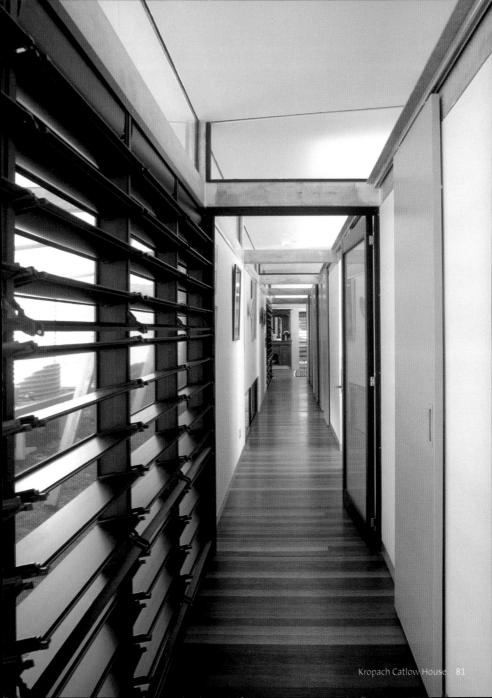

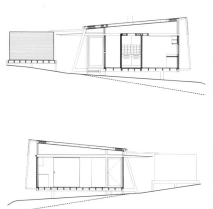

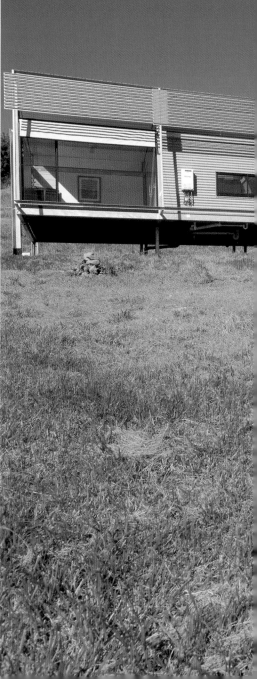

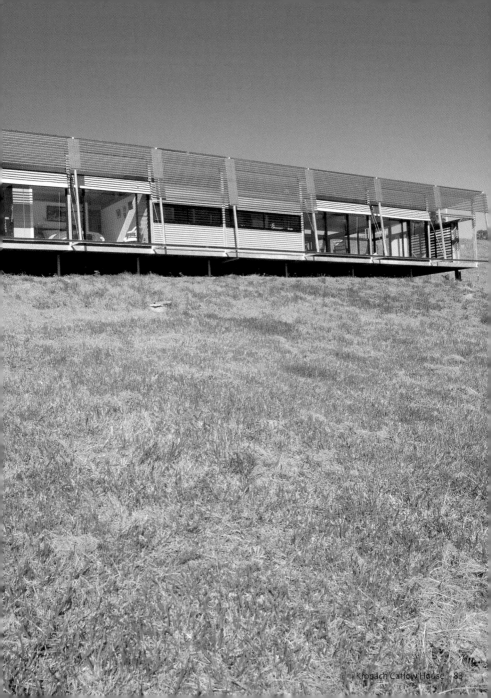

Kurimoto Millennium City Katori-City, Chiba-Prefecture I Japan

Architecture: Hiroshi Iguchi
Kamishakujii, Nerima-ku, Tokyo, Japan
www.npo-mc.com
Photos: Kazuki Ono

This compact village was constructed to offer families shared housing in a non-urban environment. The homes—spacious compared to Tokyo dwellings—enjoy natural ventilation and shade from overhanging trees. Millennium City is also intended to be a refuge when urban density threatens quality of life.

Dieses kompakte Dorf wurde errichtet, um Familien gemeinschaftliches Wohnen in einer nicht urbanen Umgebung zu ermöglichen. Die Eigenheime – gegenüber Wohnungen in Tokio vergleichsweise geräumig – profitieren von natürlicher Belüftung und Schatten durch überhängende Bäume. Millennium City ist auch als Zufluchtsort gedacht, sobald die urbane Dichte die Lebensqualität einzuschränken droht.

Ce village compact a été construit pour offrir aux familles un logement commun dans un environnement non urbain. Les logements – spacieux, comparés aux habitations tokyoïtes – bénéficient d'une ventilation et d'une ombre naturelles grâce aux arbres les surplombant. La Millennium City est aussi conçue pour être un refuge quand la densité urbaine menace la qualité de vie.

Este compacto poblado se erigió con el fin de ofrecer a las familias un conjunto residencial compartido en un entorno no urbano. Las viviendas, amplias comparadas con las de Tokio, disfrutan de ventilación natural y de la sombra de los árboles circundantes. Asimismo, se ha concebido como refugio ante la amenaza que el crecimiento urbano supone para la calidad de vida.

Questa compatta cittadina è stata creata per offrire alle famiglie una residenza in un ambiente non urbano. Le case sono spaziose se confrontate con quelle di Tokyo, con ventilazione naturale e ombra dagli alberi sovrastanti. Millennium City è anche un rifugio se la densità urbana minaccia la qualità della vita.

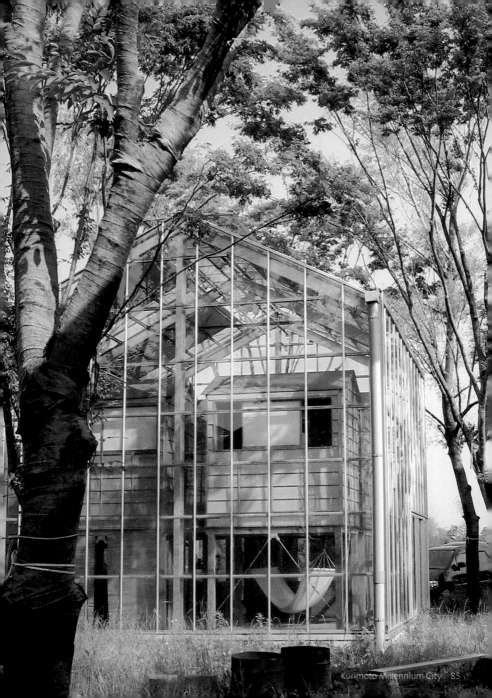

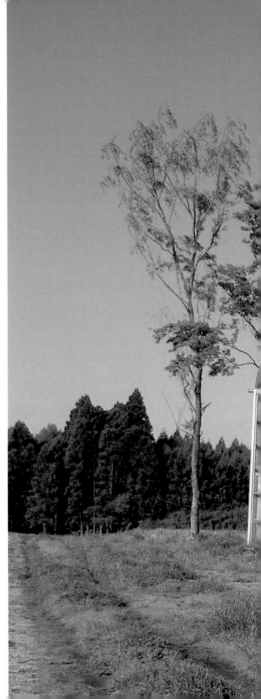

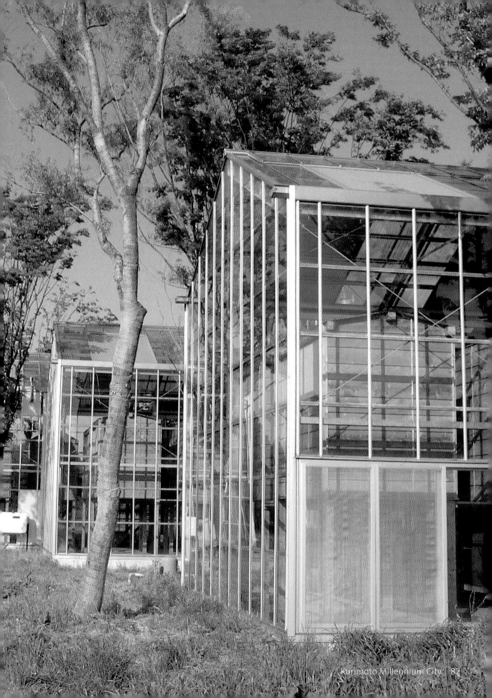

House at Lake Constance

Architecture: k_m architektur
Bregenz, Austria
www.k-m-architektur.com
Photos:Markus Tretter/Lindau

With a spectacular view of the water, this house keeps company with the elements, using concrete, glass and wood as structural material. A combination of geothermal heating and rooftop photovoltaic panels produce most of the energy for the home, supplemented by a stove in the living room.

Konstruiert aus den Baumaterialien Beton, Glas und Holz und mit einem spektakulären Blick auf das Wasser, bietet dieses Haus Begegnungen mit den Naturgewalten. Eine Kombination aus geothermischer Heizung und photovoltaischen Platten auf dem Dach erzeugt die meiste Energie für das Haus, ergänzt durch einen futuristisch anmutenden Kamin im Wohnzimmer.

Bénéficiant d'une vue spectaculaire sur l'eau, cette maison, dont les matériaux de construction sont le béton, le verre et le bois, s'appuie sur les forces de la nature. Une combinaison de chauffage géothermique et de panneaux photovoltaïques sur le toit produit l'essentiel de l'énergie de la maison, complétée par une cheminée dans la salle de séjour.

Con unas espectaculares vistas al lago, esta casa armoniza con los elementos a través del empleo de cemento, vidrio y madera como materiales estructurales. La combinación de calefacción geotérmica y placas fotovoltaicas en el tejado genera la mayor parte de la energía necesaria para la vivienda, que se completa con la chimenea de carácter futurista de la sala de estar.

Con spettacolare vista sull'acqua, questa casa ci fa compagnia con gli elementi, usando cemento, vetro e legno come materiali strutturali. Una combinazione di riscaldamento geotermico e pannelli solari fotovoltaici producono il grosso dell'energia domestica, completati da una stufa nel soggiorno.

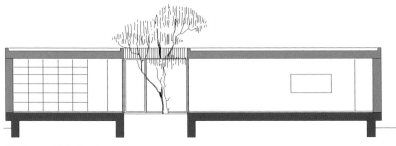

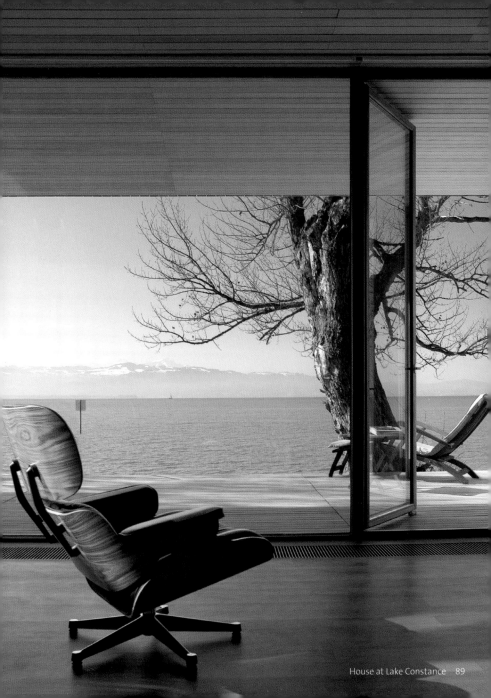

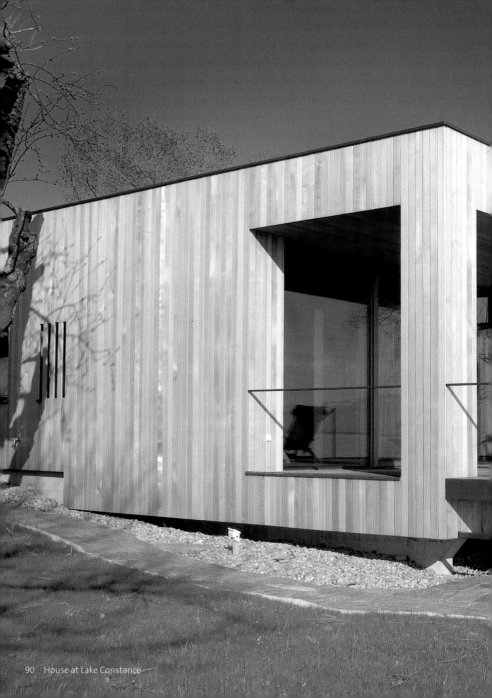

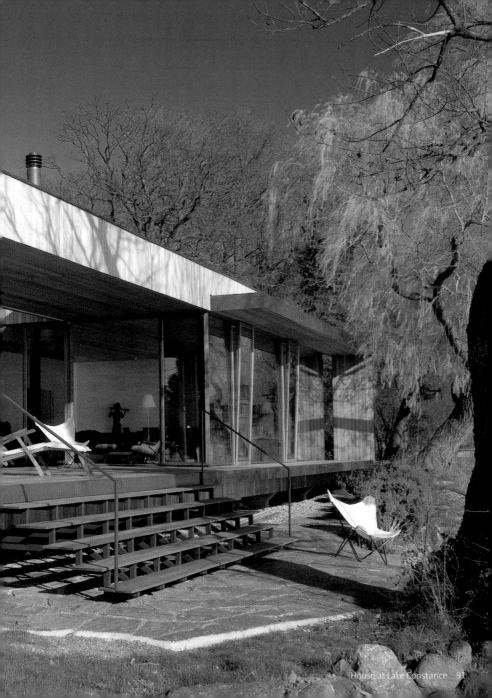

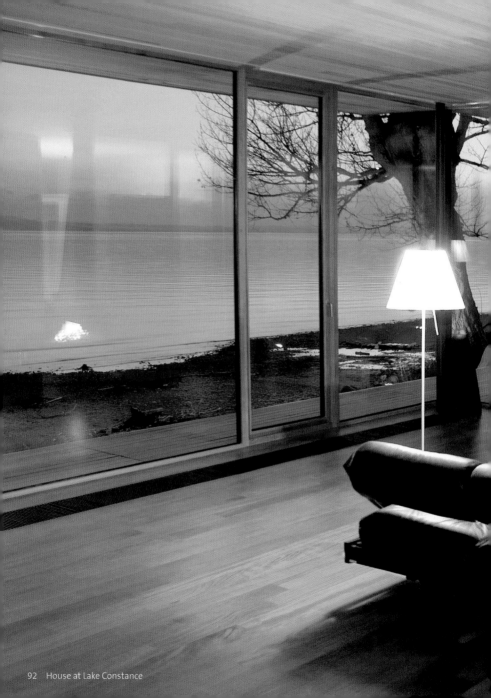

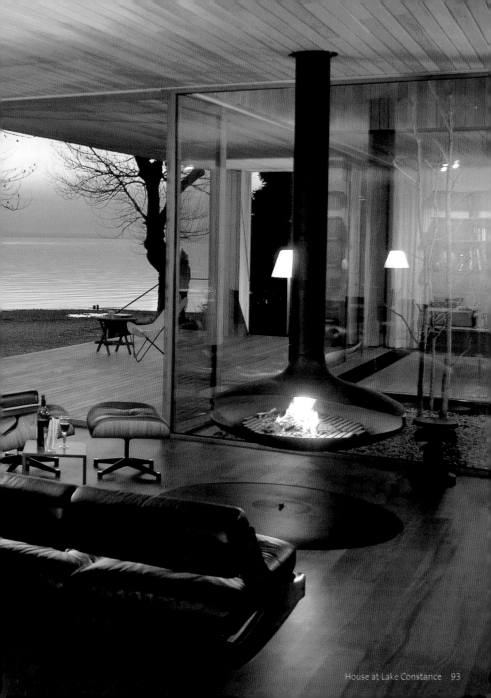

House with Panoramic View

<div align="right">Bregenz I Austria</div>

Architecture: k_m architektur
Bregenz, Austria
www.k-m-architektur.com
Photos: k_m architektur

Like its oceanfront sister, House at Lake Constance, this house boasts huge views over a vast natural landscape—this time in the mountains. The wrap-around deck, built primarily with locally sourced wood, provides a spacious meeting point between the home and the hillside.

Wie sein zum Wasser hin orientiertes Pendant, das Wohnhaus am Bodensee, imponiert dieses Haus durch großartige Aussichten auf eine weitläufige, natürliche Landschaft – dieses Mal im Gebirge. Die rundum laufende Terrasse, hauptsächlich aus einheimischem Holz gefertigt, bietet einen geräumigen Treffpunkt zwischen Haus und angrenzendem Hang.

Comme sa sœur au bord de l'eau, House at Lake Constance, cette maison offre une vue fantastique sur un vaste paysage naturel – cette fois-ci en montagne. La terrasse, entourant la maison et construite essentiellement avec du bois autochtone, constitue un lieu de rencontre spacieux entre la maison et les collines.

Al igual que su hermana al margen del lago Constanza, esta casa impone también por sus extraordinarias vistas, en este caso al vasto paraje natural de las montañas. La terraza integral, en su mayor parte de maderas autóctonas, sirve de espacioso punto de encuentro entre la vivienda y la ladera.

Come la sua sorella sull'acqua, House at Lake Constance, questa dimora vanta viste smisurate su un vasto panorama naturale, in questo caso in montagna. La terrazza perimetrale, costruita principalmente con legno di provenienza locale, offre uno spazioso punto d'incontro tra la casa e le colline.

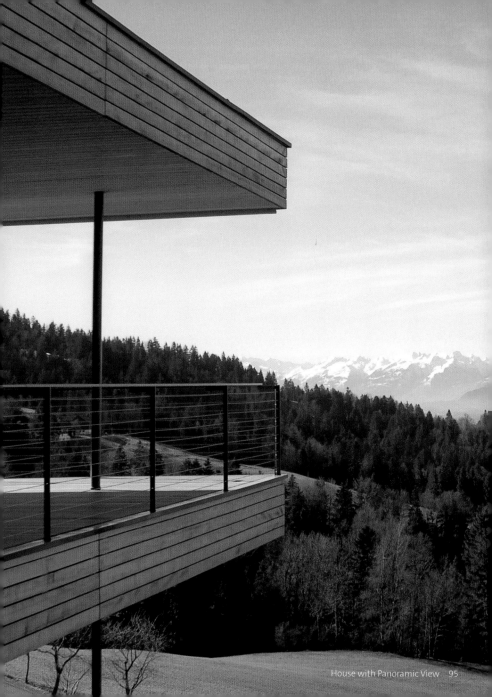

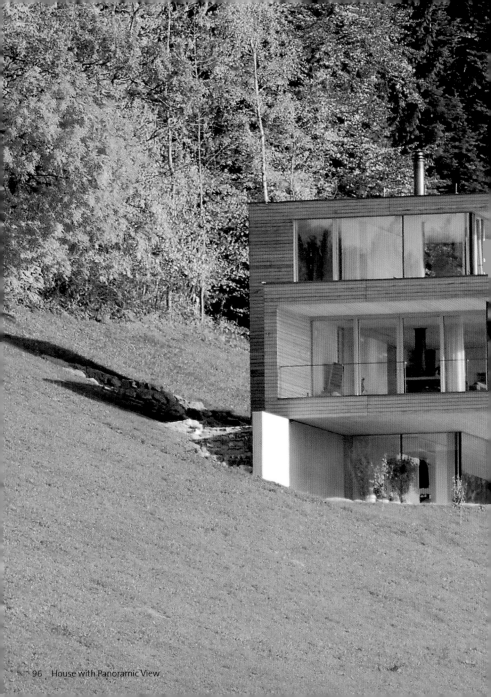

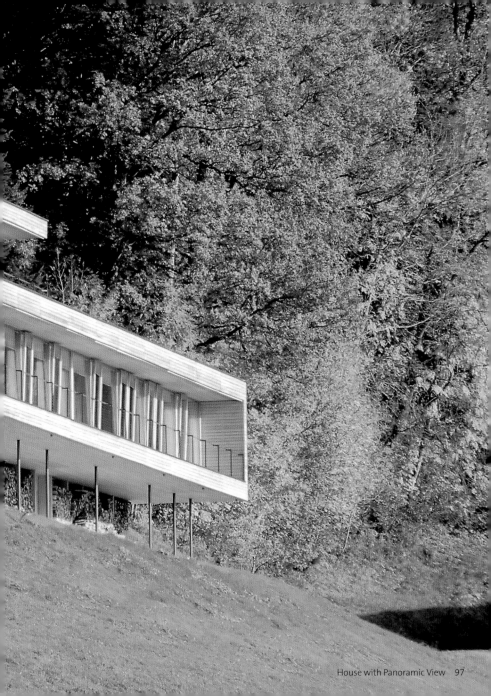

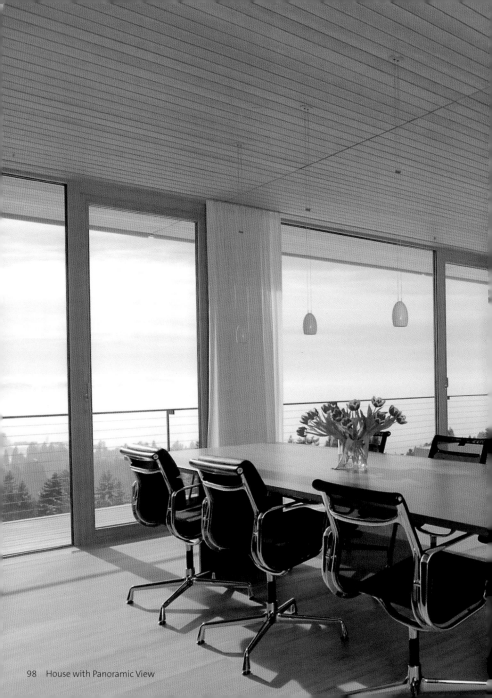

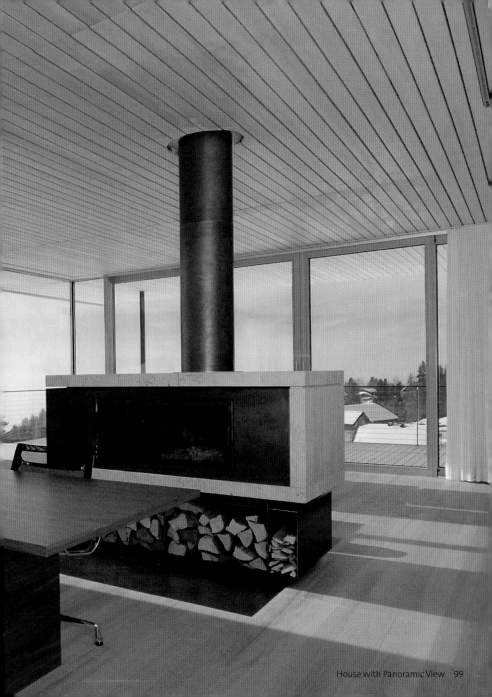

Weiss House

Architecture: LP architektur ZT GmbH & Arch. Pedevilla
Radstadt, Austria
www. lparchitektur.at
Photos: Rupert Steiner

The eye-catching Weiss House has a uniquely textured exterior, achieved through the use of untreated cedar shingles over prefabricated solid wood components. Thoughtfully placed windows and natural fiberboard insulation earned the house official recognition in Salzburg Province for energy efficiency.

Wegen seiner einzigartig strukturierten Fassade ist das Weiss House ein echter Blickfang. Der Aha-Effekt wurde durch die Verwendung von unbehandelten Zedernholzschindeln, die auf vorgefertigten Massivholzbauteilen montiert sind, erreicht. Wegen seiner energieeffizienten Bauweise mit sorgfältig platzierten Fenstern und einer Dämmung aus natürlichen Faserplatten erlangte das Haus die amtliche Anerkennung des Landes Salzburg.

La maison Weiss accroche l'œil à cause de la structure unique de sa façade pour laquelle furent utilisés des bardeaux de cèdre non traité sur des composants en bois massif préfabriqués. Ses fenêtres placées stratégiquement et son isolation par panneaux de fibres naturelles lui ont valu une reconnaissance officielle de la province de Salzburg pour son efficacité énergétique.

La excepcional textura del exterior de la espectacular Weiss House es el resultado de emplear tejas de cedro natural dispuestas sobre paneles prefabricados de madera maciza. Gracias a la elaborada disposición de las ventanas y al aislante de aglomerado natural, la casa obtuvo un galardón en la provincia de Salzburgo por su eficiencia energética.

L'affascinante Weiss House presenta esterni dalla struttura unica, ottenuta con perlinature in cedro su componenti prefabbricate in legno massiccio. Con finestre sapientemente disposte e pannelli isolanti in fibre naturali, la casa si è guadagnata un riconoscimento ufficiale della provincia di Salisburgo per l'efficienza energetica.

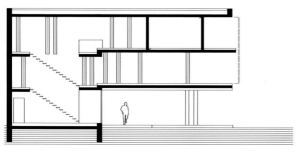

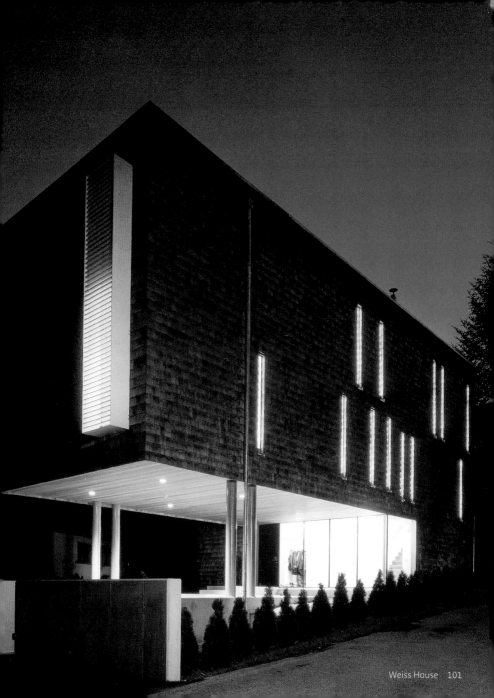

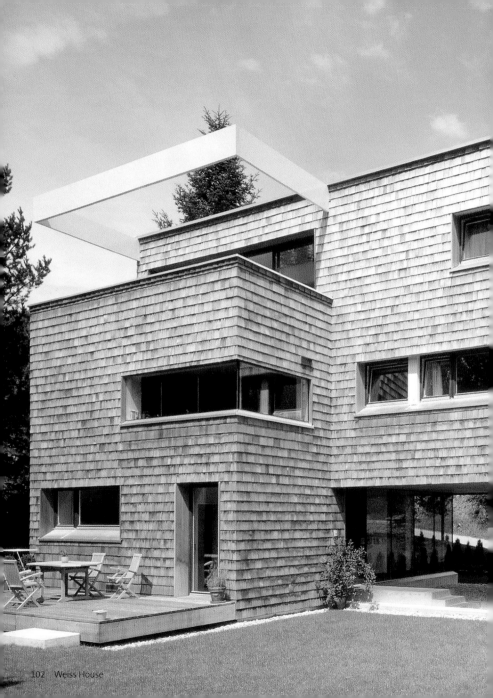

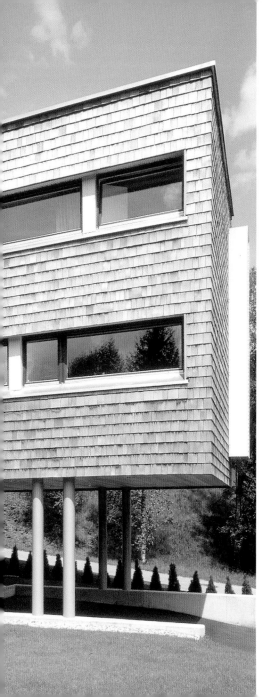

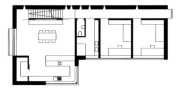

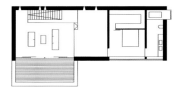

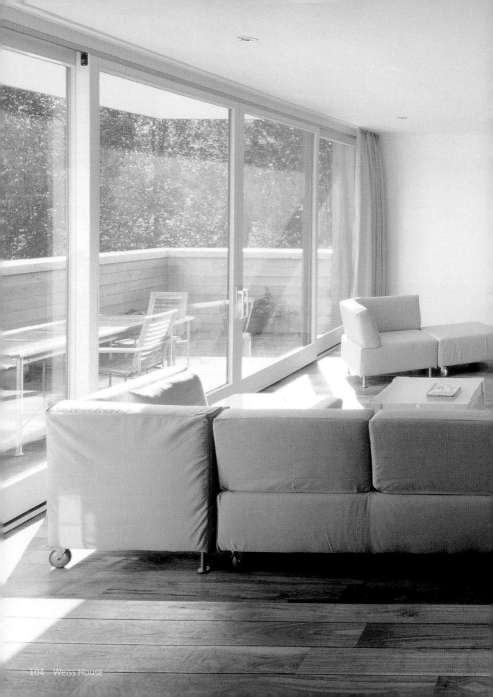

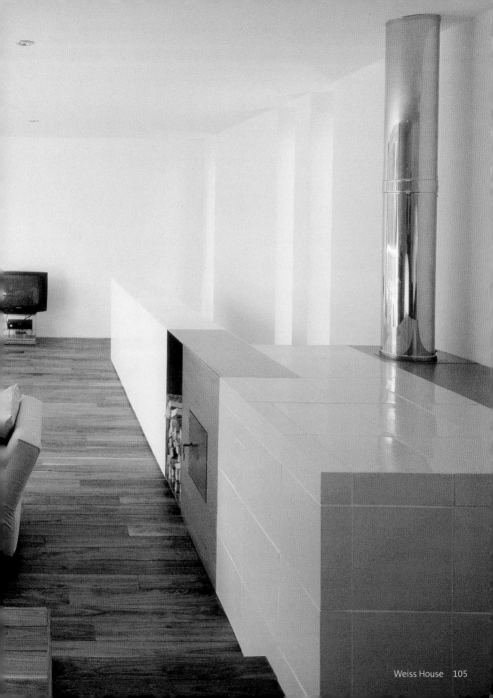

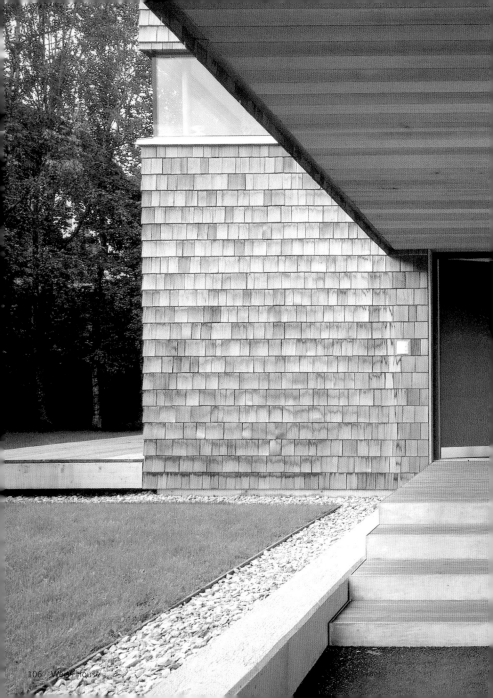

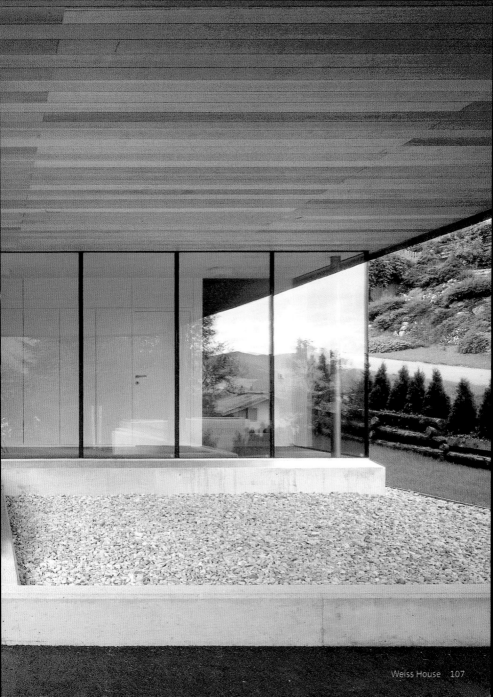

Schnitzer Bruch House

Mühlgraben I Austria

Architecture: maaars_architecture
Innsbruck, Austria
www.maaars.at
Photos: Bruno Klomfar

Perched at high elevation with expansive views, this house is characterized as a fusion of traditional and high-tech. The typical Austrian technique using massive wood blocks has been updated through prefabrication. Solar panels and daylighting add modern elements of environmental responsibility.

Auf einer Höhe gelegen, besticht dieses Haus durch seine weitläufigen Aussichten sowie die Verschmelzung von Tradition und Hightech. Die typische, traditionell österreichische Bauweise mit Massivholzblöcken bekommt durch die Fertigbauweise einen modernen Touch. Sonnenkollektoren und eine großzügige Nutzung des Tageslichtes sind moderne, umweltbewusste Elemente.

Perchée en hauteur avec une vue imprenable, cette maison se caractérise par la fusion de la tradition et du high-tech. Le mode de construction typiquement autrichien consistant à utiliser des blocs de bois massif a été modernisé par le recours au préfabriqué. Des panneaux solaires et l'utilisation de la lumière du jour sont les éléments contemporains de la responsabilité environnementale.

Esta casa encaramada en un promontorio con vastas panorámicas se caracteriza por fundir lo tradicional con la tecnología punta. La típica técnica austriaca que utiliza grandes bloques de madera se ha actualizado por medio de los prefabricados. Las placas solares y el empleo intenso de la luz diurna constituyen la moderna aportación a la responsabilidad medioambiental.

Appollaiata in alto con amplissime viste, questa casa è caratterizzata da una fusione fra high-tech e tradizione. La tipica tecnica austriaca dei blocchi in legno massiccio è stata aggiornata attraverso la prefabbricazione. I pannelli solari e l'illuminazione naturale aggiungono elementi moderni di responsabilità ambientale.

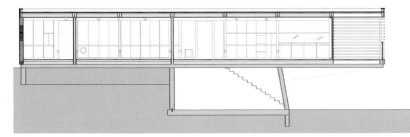

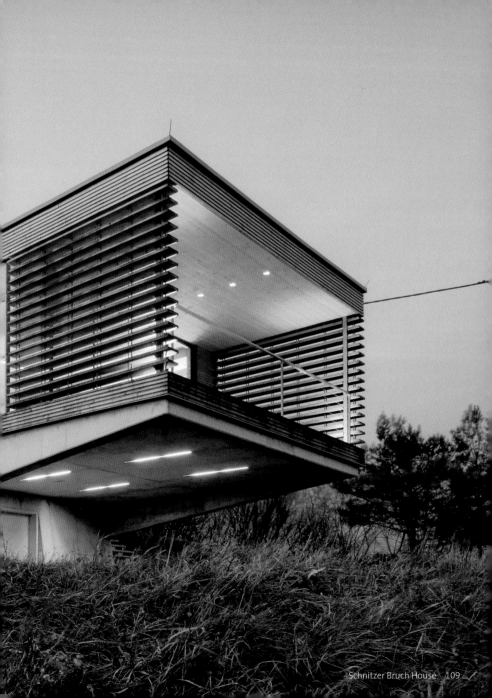

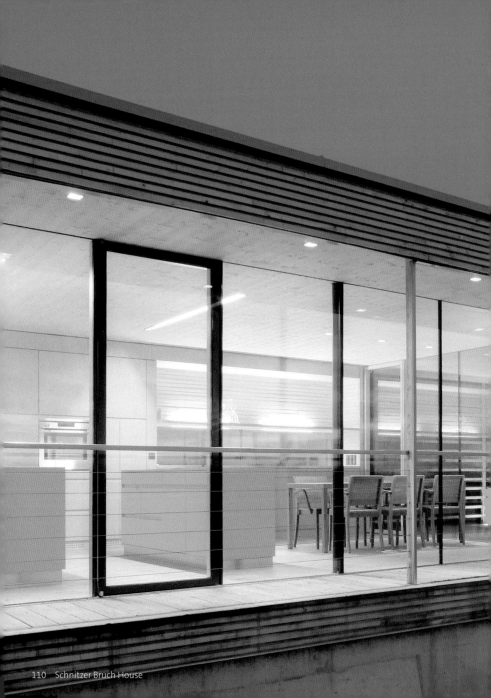

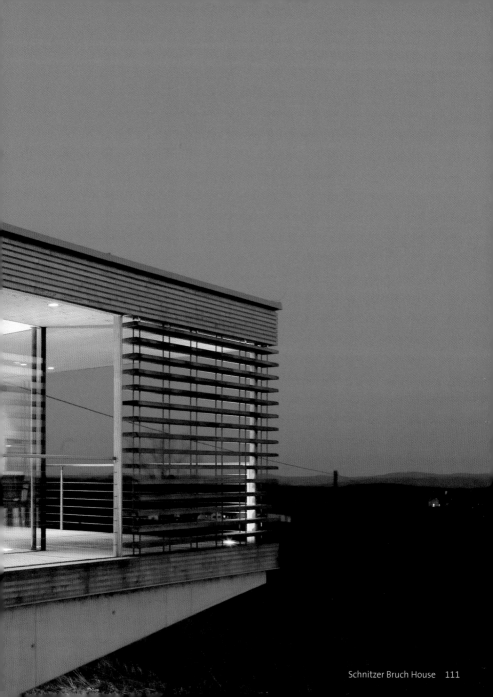

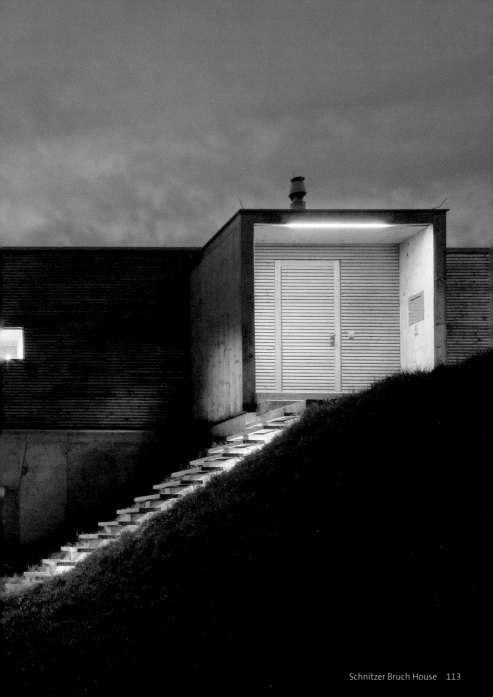

Minarc House

Architecture: Minarc – Tryggvi Thorsteinsson and Erla Dögg Ingjaldsdóttir
Santa Monica, California, USA
www.minarc.com
Photos: Torfi Agnarsson (page 115), Ralf Seeburger (page 116)

This Los Angeles home gets ecological by going nude. Exposed drywall leaves the place free of paint and its toxins, reused tires become brightly-colored kitchen surfaces, and an outdoor dining room imposes no buffer between the inhabitants and the elements (which are mild in Southern California).

Dieses Wohnhaus in Los Angeles ist ökologisch, weil es „nackt" daherkommt. Unverputzte Trockenbau-wände halten die Räume frei von Farbe und den darin enthaltenen Giftstoffen, wiederverwendete Reifen sind zu leuchtendfarbigen Küchenoberflächen geworden und ein Esszimmer im Freien vereint die Bewohner mit der Natur (im Süden Kaliforniens ist das Klima recht mild).

Cette maison de Los Angeles est écologique parce qu'elle reste nue. Grâce aux cloisons sèches apparentes, les lieux sont exempts de peinture et des toxines qu'elle contient; des pneus réutilisés se transforment en surfaces de cuisine aux couleurs brillantes et une salle à manger en plein air abolit la séparation entre les habitants et les éléments (qui sont cléments dans le sud de la Californie).

Esta casa de Los Ángeles se convierte en ecológica al "desnudarse". La construcción en seco *drywall* prescinde de las pinturas y sus toxinas; unos neumáticos viejos se reutilizan como superficies llenas de color en la cocina y el comedor exterior suprime barreras entre los habitantes y los elementos exteriores, que son de lo más suaves en el sur de California.

Questa residenza di Los Angeles diventa ecologica spogliandosi. Il muro a secco a vista la libera dalla vernice e relative tossine, pneumatici riciclati diventano superfici da cucina a colori vivaci, e una sala da pranzo esterna non impone barriere tra gli abitanti e i miti elementi della California del Sud.

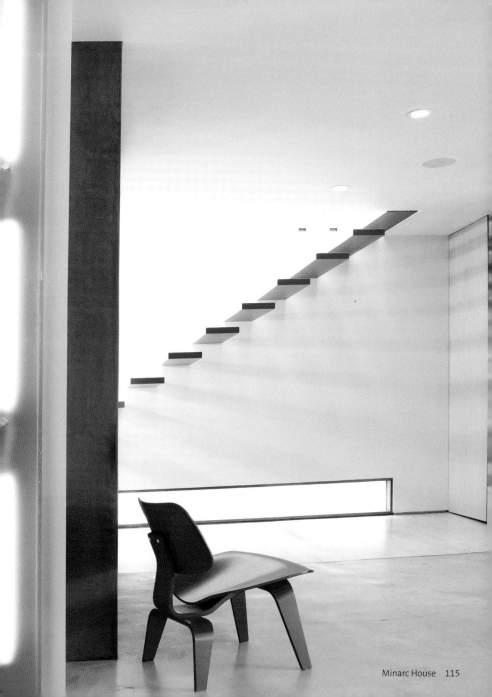

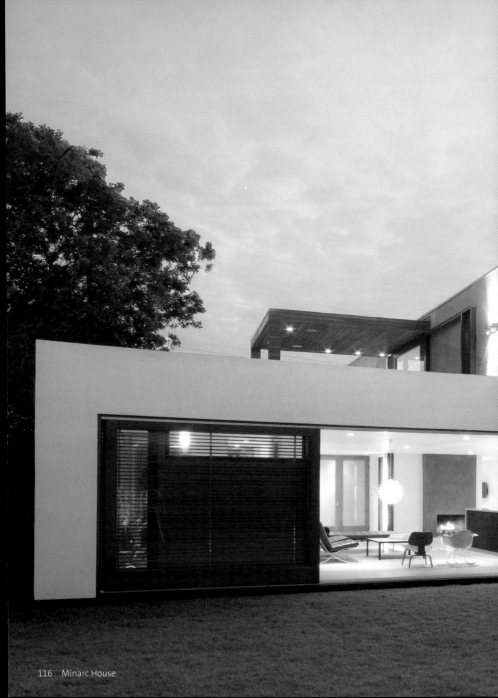

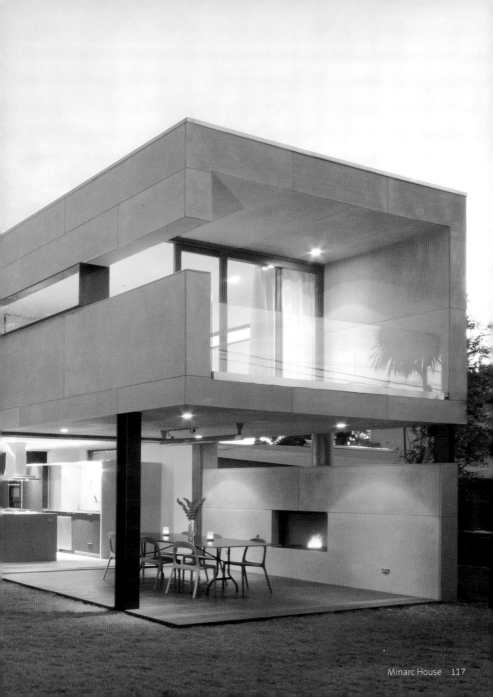

Oregon Coast House

Gold Beach, Oregon I USA

Architecture: Obie G. Bowman
Healdsburg, California, USA
www.obiebowman.com
Photos: Tom Rider

The Oregon Coast House resembles oversized driftwood braving the wind on the shore. Buttressed externally with giant logs, its interior walls are made from local wood and sliding doors are stained with garden fertilizer and sealed with beeswax. Glazing, shades and a ventilation shaft work together to keep the climate consistent.

Das Oregon Coast House erinnert an überdimensioniertes Treibholz, das dem Wind an der Meeresküste trotzt. Außen von gigantischen Holzstämmen gestützt, wurden seine Innenwände aus lokalem Holz gefertigt und die Schiebetüren mit Gartendünger eingefärbt und mit Bienenwachs versiegelt. Die Verglasung in Verbindung mit Blenden und einem Belüftungsschacht halten das Raumklima konstant.

L'Oregon Coast House ressemble à un immense morceau de bois flottant, bravant le vent sur le rivage. Renforcés à l'extérieur par des bûches géantes, les murs intérieurs peints sont construits avec du bois local et les portes coulissantes sont teintes à l'engrais de jardin et liées à la cire d'abeille. Des vitrages, des écrans de protection et un puits de ventilation s'associent pour maintenir une température constante.

La Oregon Coast House se asemeja a un gran tronco en el mar que el viento ha arrastrado hasta la orilla. La vivienda está apuntalada con unos gigantescos contrafuertes exteriores, la tabiquería interior es de madera autóctona y las puertas correderas están teñidas con fertilizante de jardinería y selladas con cera de abejas. El acristalamiento, las persianas y la chimenea de ventilación actúan al unísono para mantener la temperatura.

La Oregon Coast House ricorda un enorme relitto che sfida le brezze marine. Rinforzata esternamente con travi gigantesche, le sue pareti interne sono di legno autoctono e le porte scorrevoli sono trattate con fertilizzante da giardino e sigillate con cera d'api. Le vetrate, gli scuri e una canna di ventilazione contribuiscono a una climatizzazione costante.

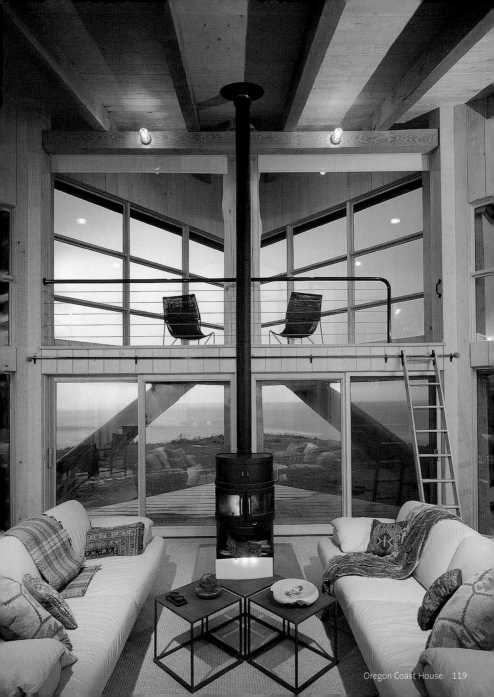

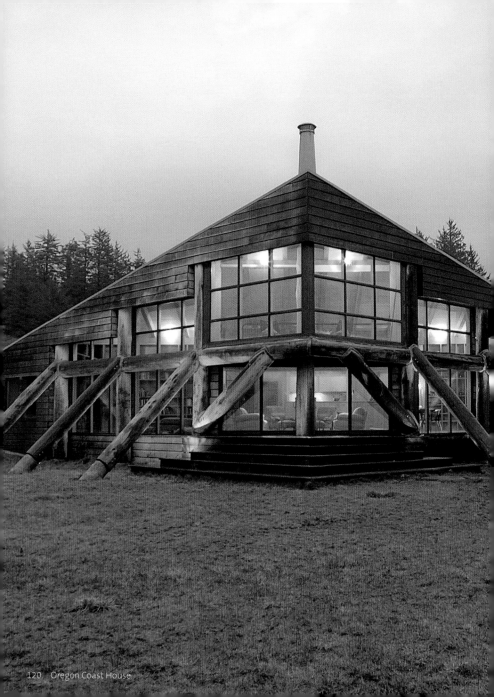

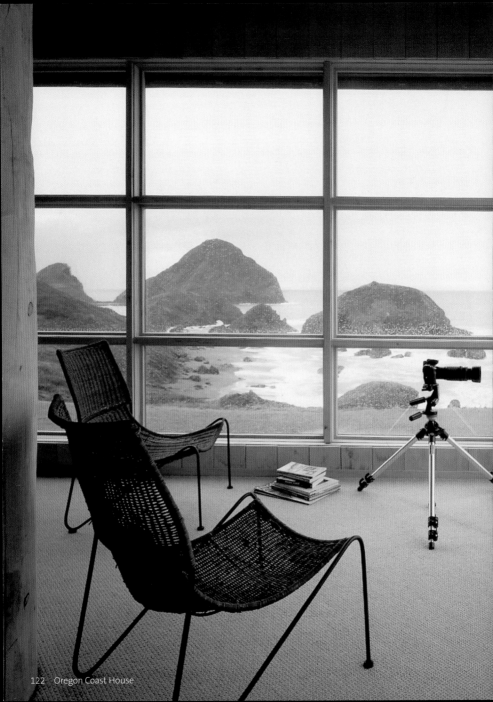

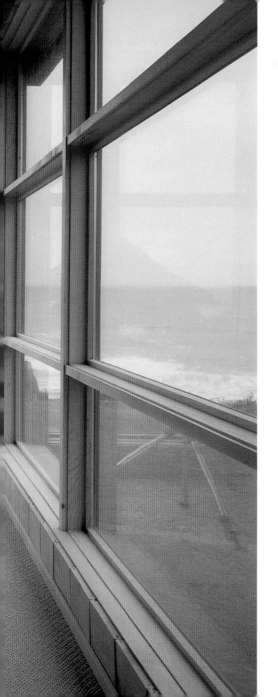

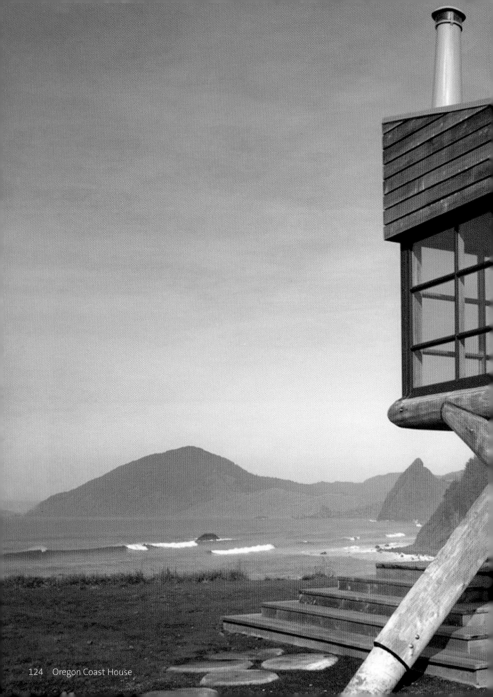

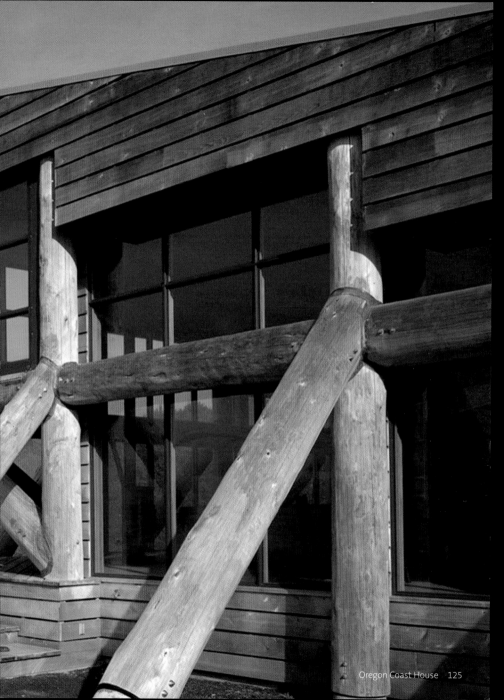

Sonoma Coast House

Architecture: Obie G. Bowman
Healdsburg, California, USA
www.obiebowman.com
Photos: Tom Rider

Originally built in 1971, this wine country vacation home endures high temperatures during summer months. To counter the need for air conditioning and other energy-intensive cooling strategies, the recent renovation of the home included ventilation chimneys that pull heat out and draw cool air in.

Ursprünglich 1971 erbaut, hält dieses in einem Weinanbaugebiet liegende Ferienhaus problemlos den hohen Temperaturen während der Sommermonate stand. Um der Notwendigkeit einer Klimaanlage und anderen energieintensiven Kühlungsmethoden vorzubeugen, wurden bei der letzten Renovierung des Hauses Belüftungsschornsteine eingebaut, welche Wärme herausleiten und kühle Luft einschleusen.

Construite à l'origine en 1971, cette maison de vacances située dans une région viticole fait face à de fortes températures durant les mois d'été. Pour contrer la nécessité d'une climatisation et d'autres méthodes de refroidissement, gourmandes en énergie, la récente rénovation de la maison a introduit des cheminées de ventilation qui expulsent la chaleur et font entrer l'air frais.

Esta vivienda vacacional construida en 1971 soporta las altas temperaturas estivales de la región vinícola en la que se ubica. Para contrarrestar la necesidad de aire acondicionado y otros sistemas de refrigeración de gran consumo, la reciente reforma incluyó chimeneas de ventilación que expulsan aire caliente y aspiran aire frío.

Costruita originariamente nel 1971, questa casa vacanze tra i vigneti sopporta alte temperature nei mesi estivi. Per venire incontro ai bisogni di aria condizionata e alle altre dispendiose strategie di raffreddamento, la recente ristrutturazione ha previsto camini di ventilazione, che estraggono l'aria calda ed immettono aria fresca.

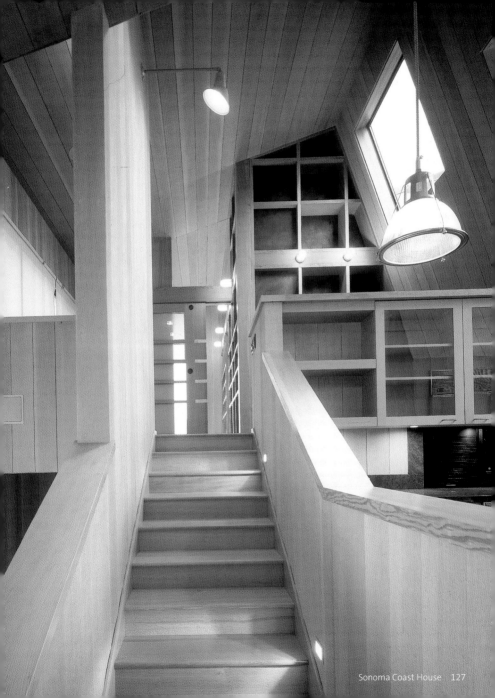

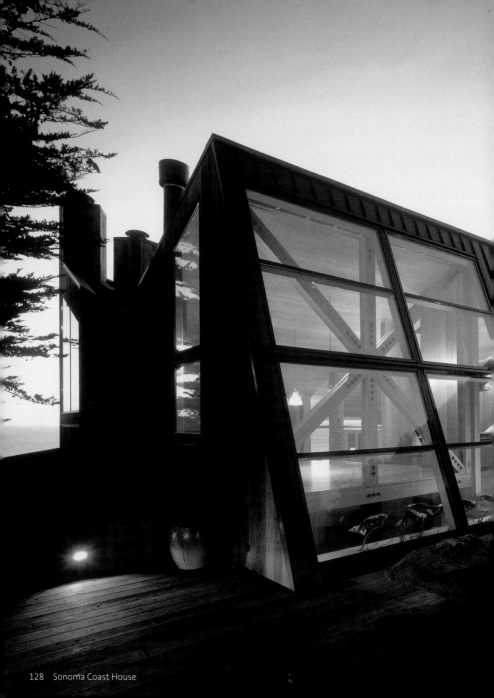

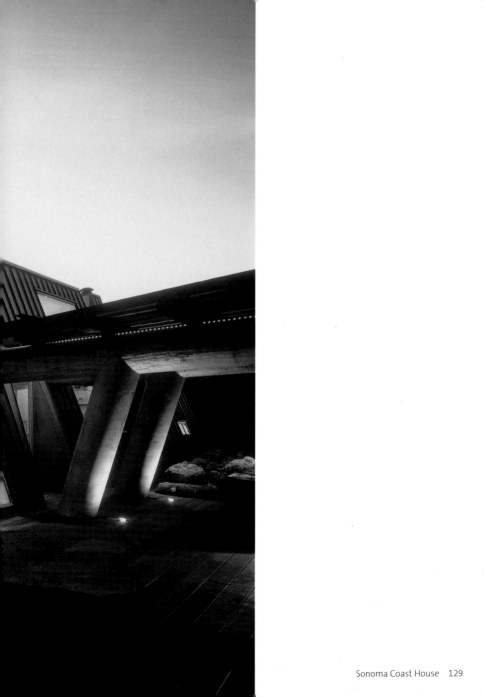

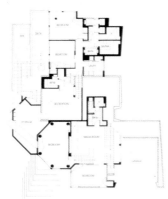

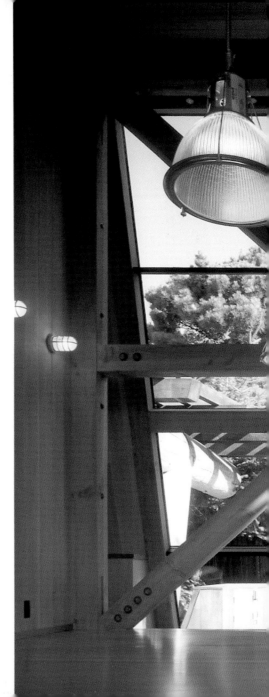

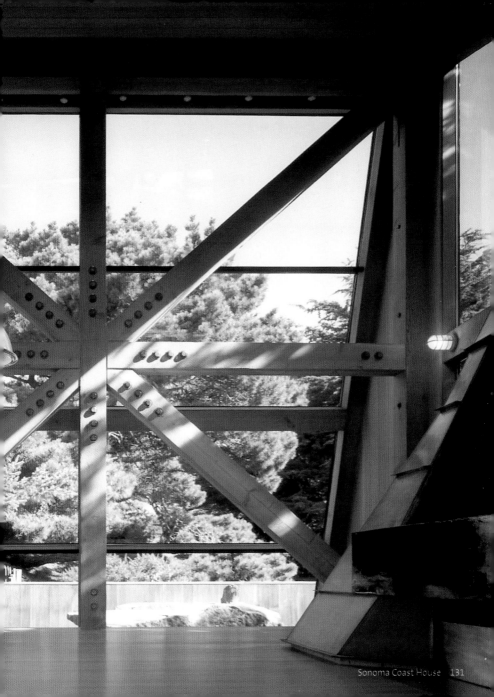

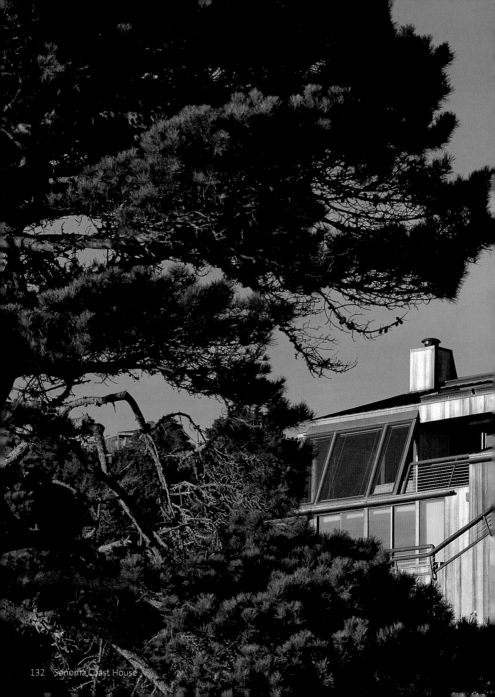

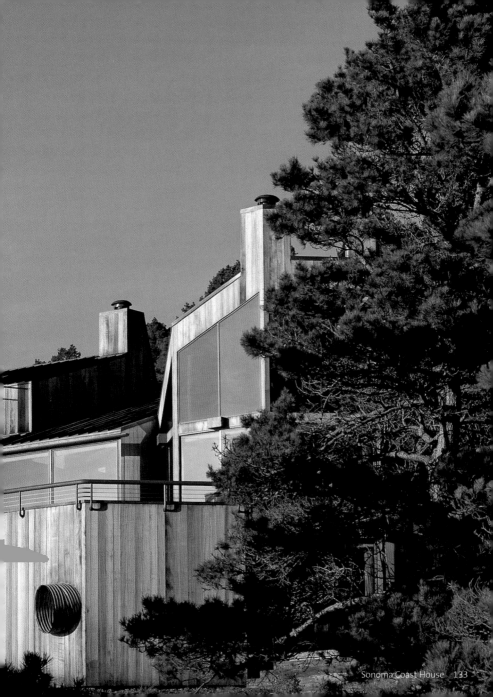

Opus House

Architecture: Opus Architekten BDA, Prof. Anke Mensing und Andreas Sedler
Darmstadt, Germany
www.opus-architekten.de
Photos: Eibe Sönnecken

When this house was expanded, its original structure gained space with a transparent, 3-story annex. A glass-made addition to the original house now connects both sections of the building. Bathed in light, the house comprises an efficient power supply system based on cutting-edge passive-house technologies as well as rooftop solar heating and photovoltaics.

Bei dieser Erweiterung wurde ein gründerzeitliches Haus durch einen transparenten, 3-geschossigen Anbau ergänzt. Eine gläserne Aufstockung des Altbaus verbindet beide Gebäudeteile. Das lichtdurchflutete Haus nutzt für eine effiziente Energieversorgung modernste Passivhaustechnologien sowie auf dem Dach befindliche Solarthermie- und Photovoltaikelemente.

Lors de son agrandissement, cette maison avec ses murs d'origine s'est vu adjoindre une annexe transparente sur 3 niveaux. Une surélévation en verre du bâtiment ancien relie les deux parties. Pour une production énergétique efficace, la maison, inondée de lumière, utilise des technologies passives ainsi que des capteurs solaires thermiques et photovoltaïques placés sur le toit.

Cuando se amplió esta casa, se añadió espacio a la estructura original con un anexo transparente de 3 plantas. Inundada de luz, la casa dispone de un sistema de energia eficiente basado en innovadoras técnologias pasivas y un sistema de calefacciòn solar con células fotovoltaicas en el tejado.

Quando questa casa è stata ingrandita, si è aggiunto spazio alla struttura originale con un annesso trasparente di 3 piani. L'annesso vetrato unisce adesso le due sezioni dell'edificio. Inondata di luce, la casa include un sistema d'energia efficiente basato su innovative tecnologie passive ed un sistema di riscaldamento solare con cellule fotovoltaiche sul tetto.

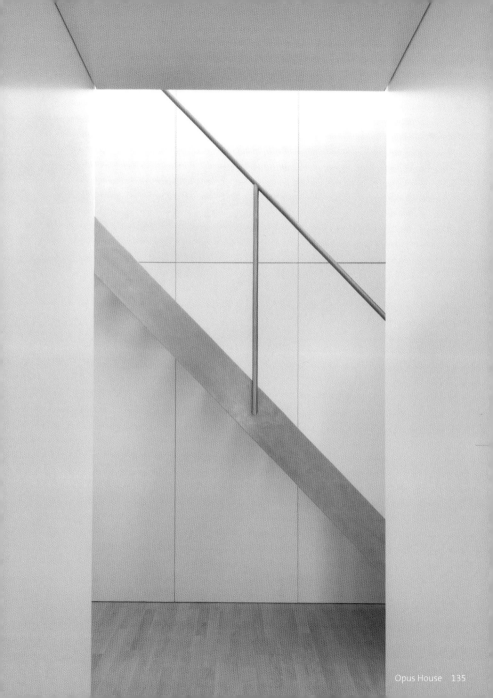

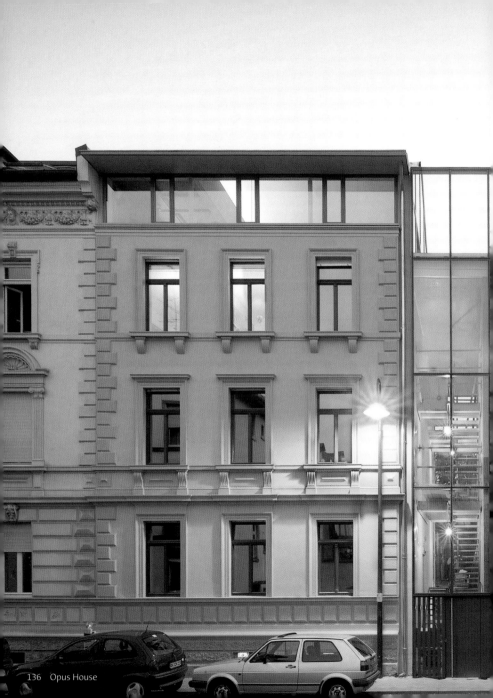

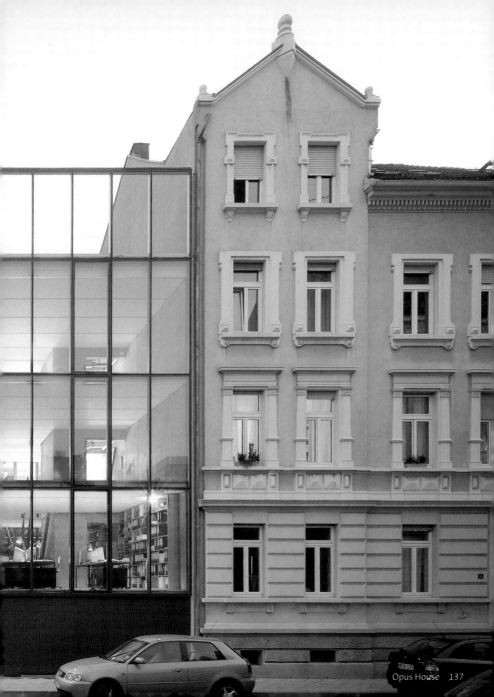

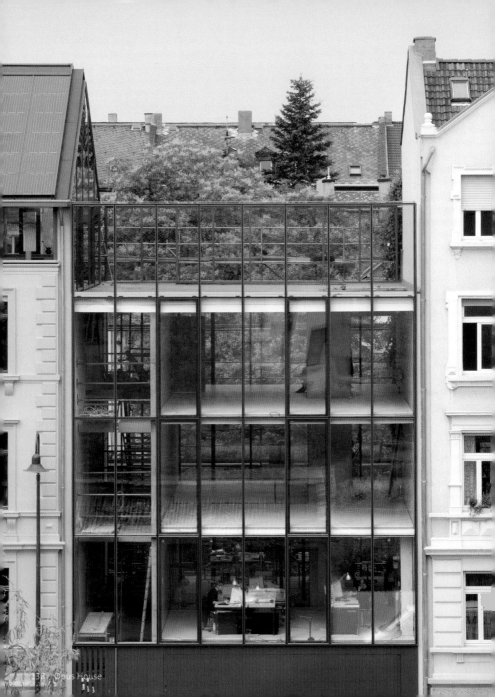

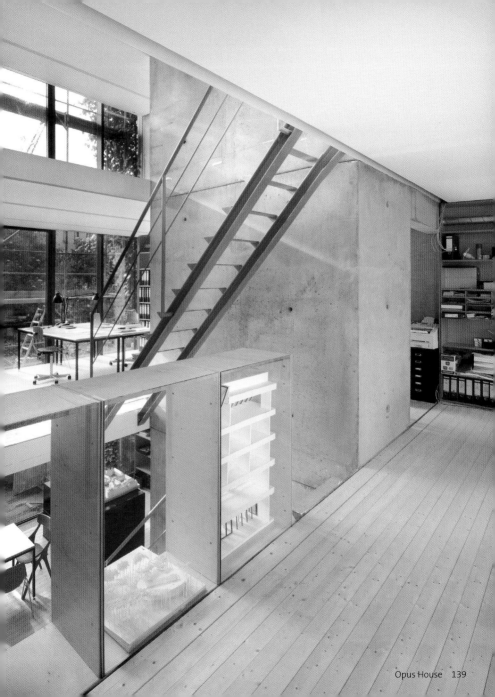

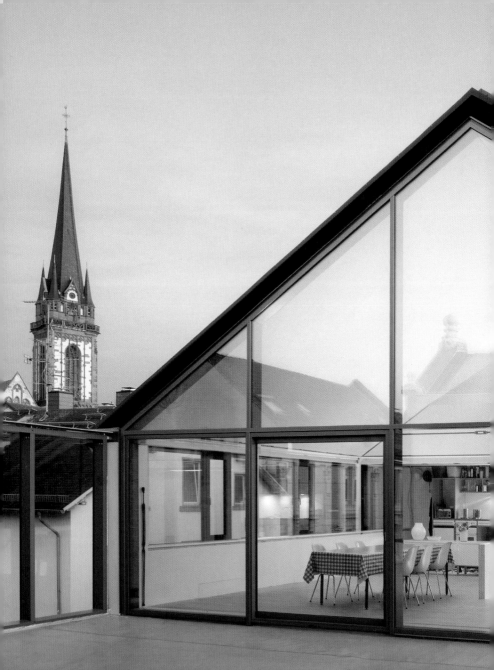

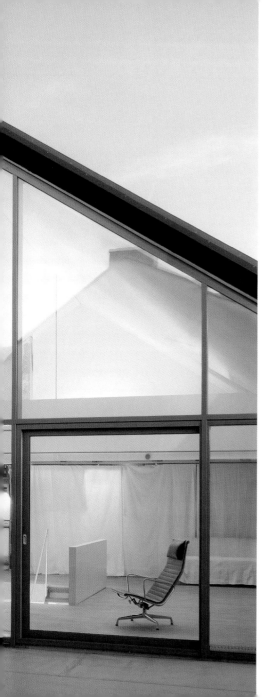

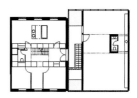

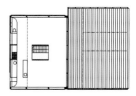

Villa Room

Rhenen I Netherlands

Architecture: Architectenbureau Paul de Ruiter b.v.
Amsterdam, Netherlands
www.paulderuiter.nl
Photos: Rob 't Hart (pages 143, 144, 149), Alessio Guarino (pages 146, 147)

The tech-savvy owners of this house chose to use a responsive system to keep their home comfortable and energy efficient. As daylight, wind and weather shift, the indoor temperature adjusts accordingly. For their remaining power needs, solar boilers and PV cells collect energy atop the green roof.

Die computererfahrenen Eigentümer dieses Hauses haben sich für ein bedarfsgerechtes System entschieden, um ihr Heim komfortabel und energiesparend zu gestalten. Da Tageslicht, Wind und Wetter wechseln, passt sich die Raumtemperatur entsprechend an. Für den restlichen Bedarf sammeln Solarheizkessel und Photovoltaikzellen auf dem begrünten Dach die Energie.

Les ingénieux propriétaires de cette maison ont choisi d'utiliser un système réactif pour que leur maison reste confortable et économe en énergie. La température intérieure s'ajuste selon les changements de lumière du jour, de vent et de climat. Pour le reste des besoins en énergie, des chaudières solaires et des cellules photovoltaïques collectent l'énergie sur le toit vert.

Los propietarios de esta casa, expertos en informática, se decidieron por un sistema muy efectivo para conseguir un hogar confortable y ecológico. La temperatura interior se ajusta en concordancia con los cambios de la luz natural, el viento y el tiempo. Las necesidades energéticas restantes se cubren con calderas solares y células fotovoltaicas que acumulan energía en el tejado verde.

Tecnologicamente preparati, i proprietari hanno scelto un sistema reattivo per mantenere la propria casa accogliente ed energeticamente efficiente. La temperatura interna si adatta alle variazioni della luce naturale, del vento e del clima. Per i restanti fabbisogni energetici, caldaie solari e celle FV raccolgono energia sul tetto verde.

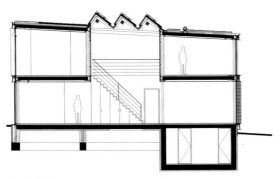

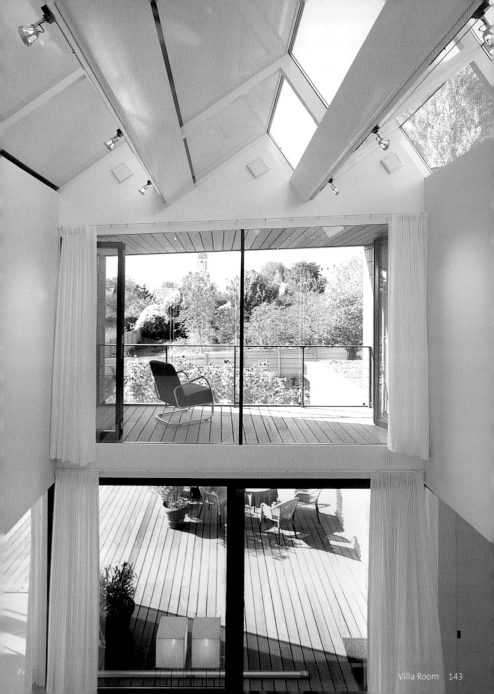

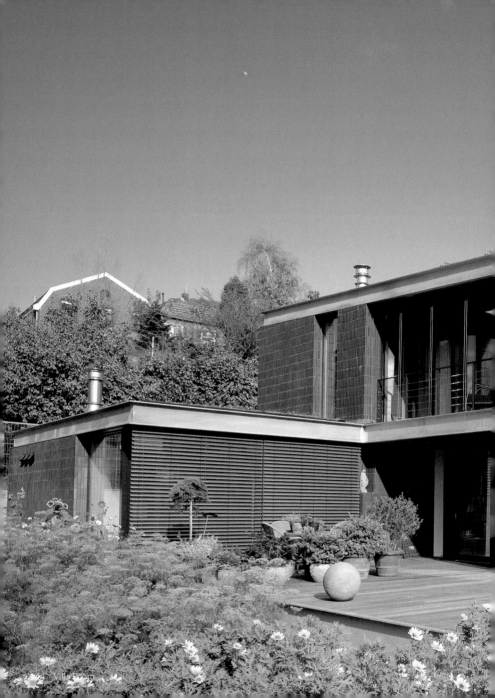

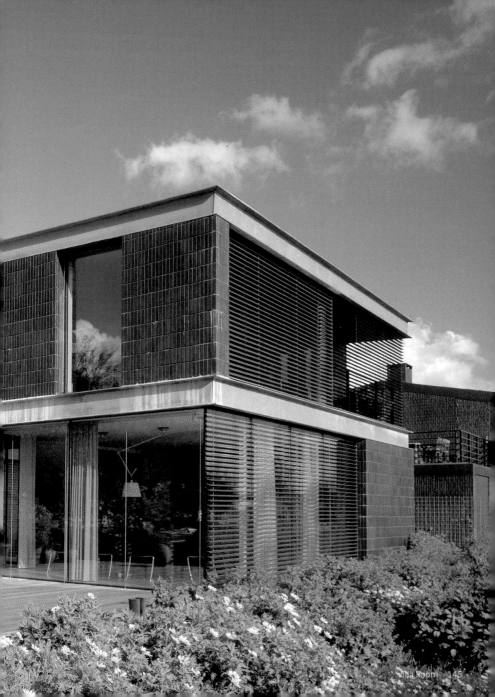

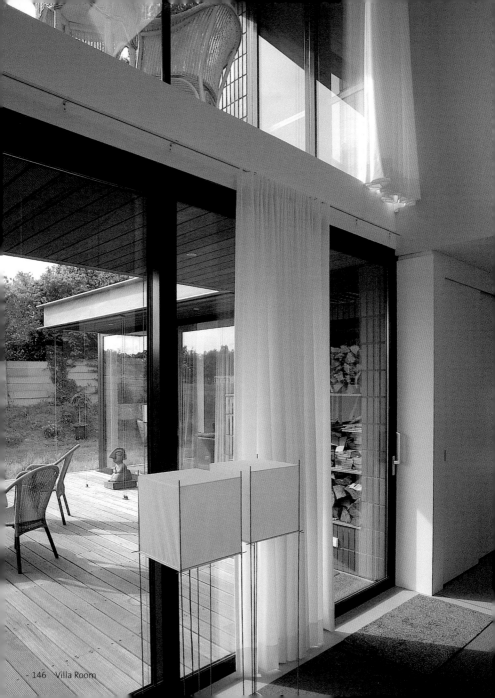

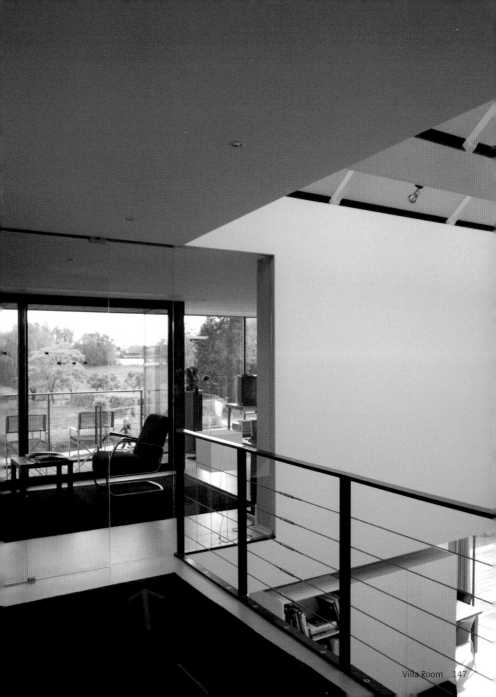

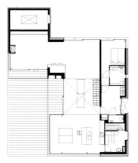

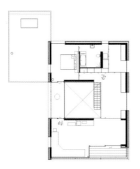

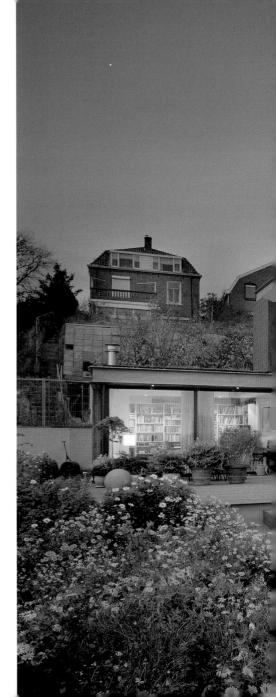

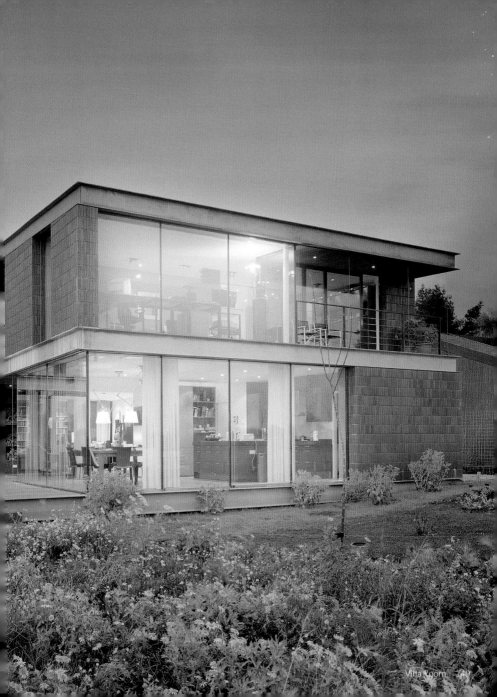

Philipp House

Architecture: philipp architekten
Untermünkheim, Germany
www.philipp-architekten.de
Photos: Oliver Schuster

Delicately positioned on a ridgeline overlooking an impressive landscape, the architects designed Philipp House using as much natural wood as possible, from the prefabricated panel walls to the wood fiber insulation. The efficient materials and well-placed windows yielded a carbon-neutral building.

Anmutig auf einem Gebirgskamm gelegen, überblickt man von diesem Haus aus eine beeindruckende Landschaft. Die Architekten benutzten für Philipp House so viel Naturholz wie möglich, von den vorgefertigten Wandplatten bis hin zur Holzfaserdämmung. Diese energieeffizienten Materialien und gut platzierte Fenstern führten zu einem CO_2-neutralen Gebäude.

Délicatement posée sur une crête montagneuse, dominant un paysage impressionnant, la Philipp House a été conçue par ses architectes pour utiliser le plus de bois naturel possible, des panneaux muraux préfabriqués à l'isolation en fibres de bois. Les matériaux efficaces et des fenêtres bien placées permettent d'obtenir un bâtiment sans production de CO_2.

Los arquitectos de la Philipp House ubicada en el alto escarpado de una colina y con impresionantes vistas, utilizaron tanta madera natural como les fue posible en su diseño, desde los paneles de paredes prefabricadas hasta el aislamiento con fibra de madera. Los eficientes materiales y la óptima disposición de las ventanas han creado un edificio sin emisiones de CO_2.

Delicatamente posata su una cresta montuosa che domina un maestoso paesaggio, gli architetti hanno progettato la Philipp House usando quanto più legno naturale possibile, dai muri in pannelli prefabbricati all'isolamento in fibre di legno. Gli efficienti materiali e le finestre ben distribuite hanno prodotto un edificio a carbonio zero.

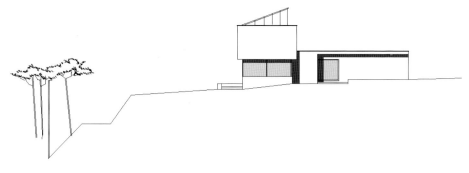

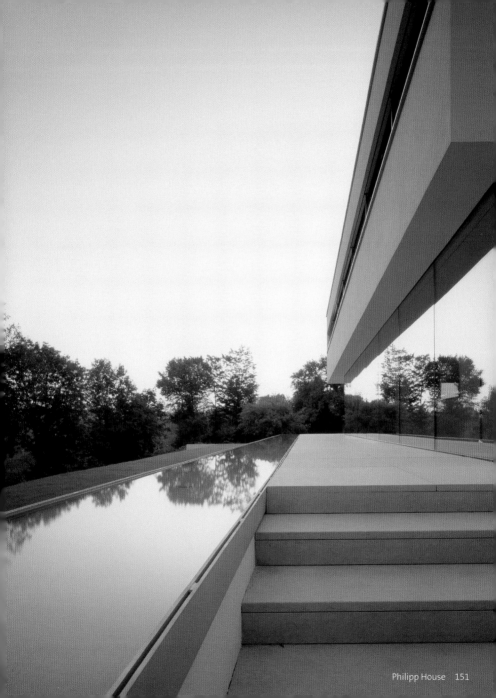

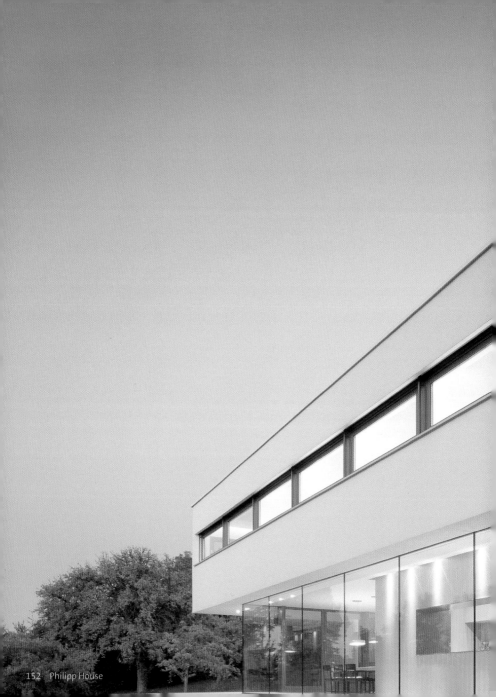

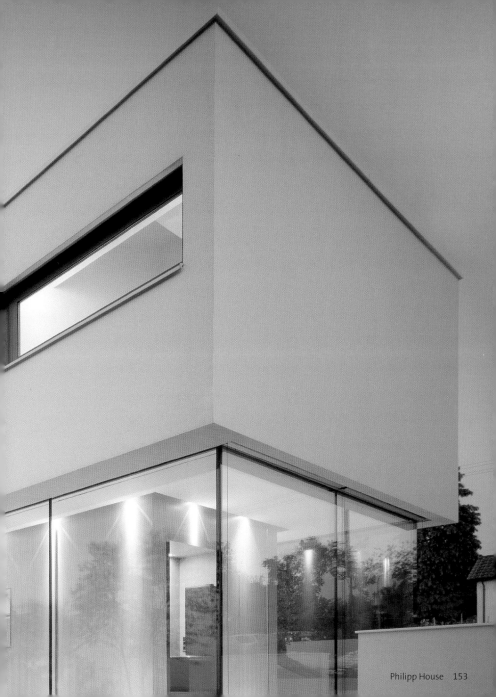

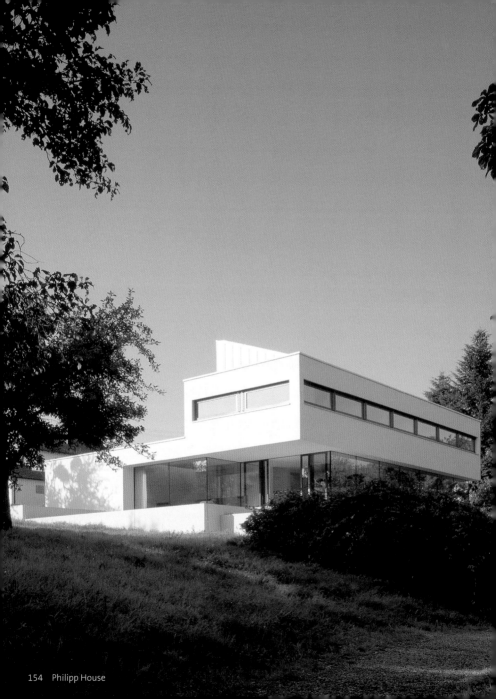

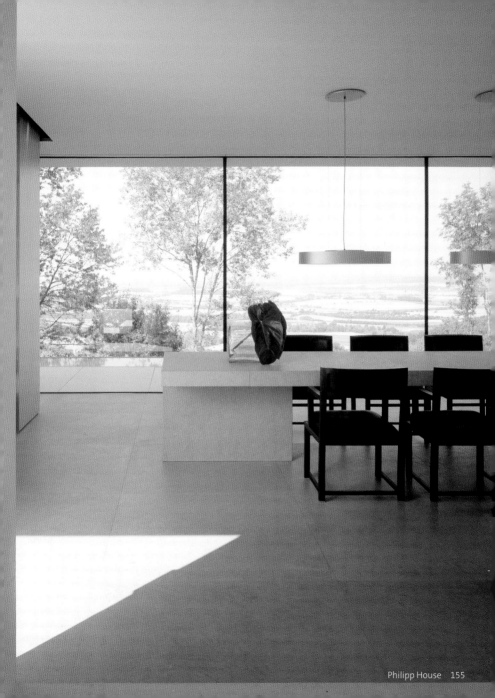

Courtyard House

<div align="right">Los Angeles, California I USA</div>

Architecture: Ripple Design
Los Angeles, California, USA
www.ripplesite.com
Photos: Marla Aufmuth

In the often hot and breezy west side of Los Angeles, Ripple Design's Courtyard House turns existing conditions into assets. As the name suggests, the house sits around a courtyard that offers privacy from wind and noise, with operable doors and solar power to keep the inside comfortable and energy bills low.

Im oftmals heißen und windigen Westen von Los Angeles hat Ripple Design diese Gegebenheiten in Vorzüge verwandelt. Wie der Name verrät, umschließt das Haus einen Hof, der die Bewohner vor Wind und Lärm schützt. Das Haus verfügt über Schiebetüren und Solarenergie, um die Innenatmosphäre angenehm zu gestalten und die Nebenkosten gering zu halten.

Dans la partie ouest souvent torride et venteuse de Los Angeles, la Courtyard House de Ripple Design transforme ces réalités en atouts. Comme son nom le suggère, la maison abrite une cour intérieure qui protège du vent et du bruit, avec des portes coulissantes et de l'énergie solaire pour garder un intérieur confortable et des factures d'énergie réduites.

En el cálido y ventoso oeste de Los Ángeles, esta casa con patio diseñada por Ripple Design convierte las condiciones existentes en ventajas. Haciendo honor a su nombre, la casa tiene como eje central un patio que protege del viento y del ruido; cuenta con puertas correderas y energía solar a fin de mantener un interior confortable y reducir gastos de electricidad.

Sul lato occidentale di Los Angeles, spesso torrido e ventoso, la Courtyard House di Ripple Design trasforma le condizioni esistenti in risorse. Come il nome suggerisce, la casa è posta attorno ad un cortile che offre intimità dal vento e dal rumore, con pratiche porte ed energia solare per mantenere gli interni accoglienti e le bollette moderate.

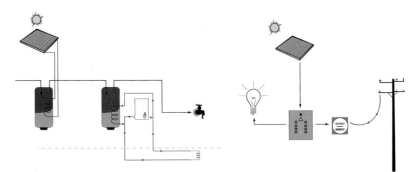

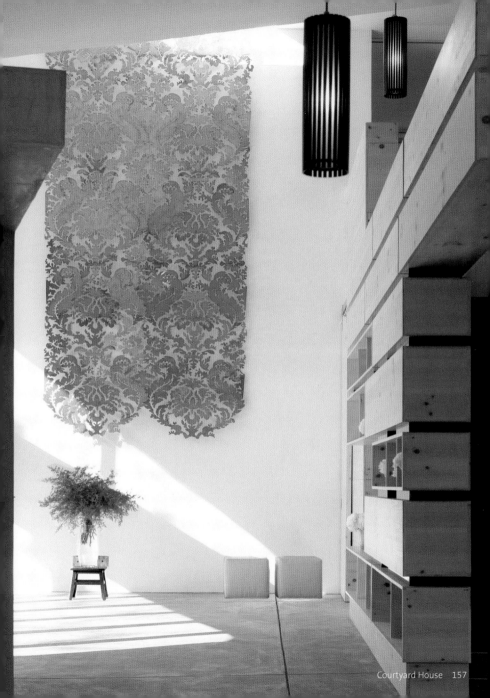

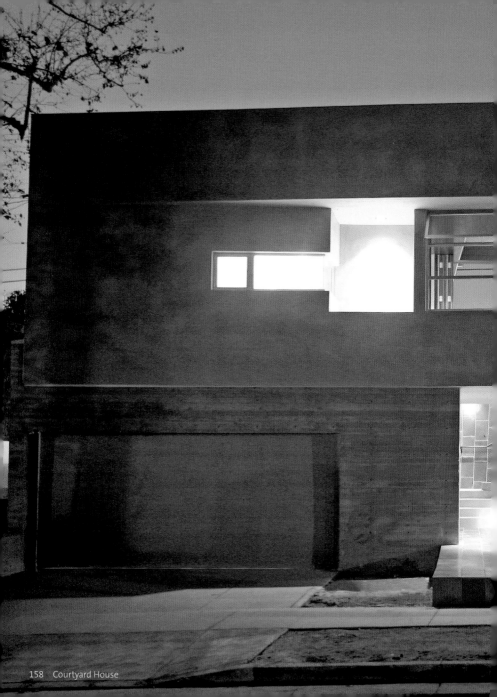

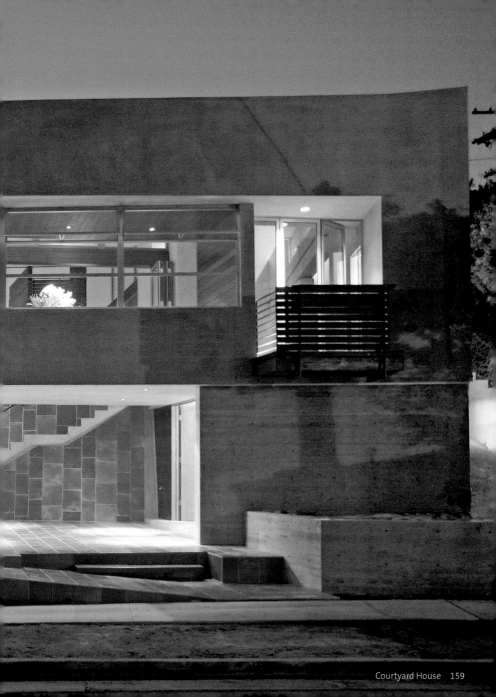

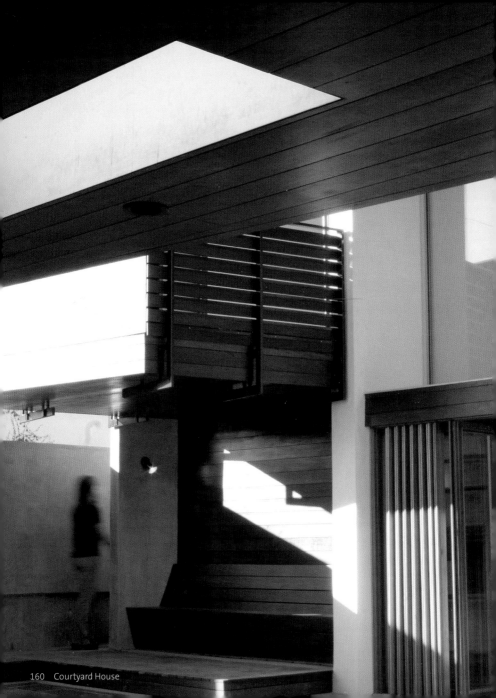

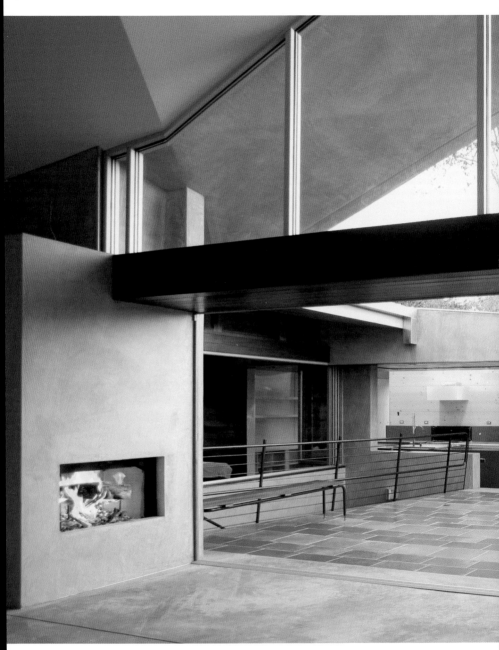

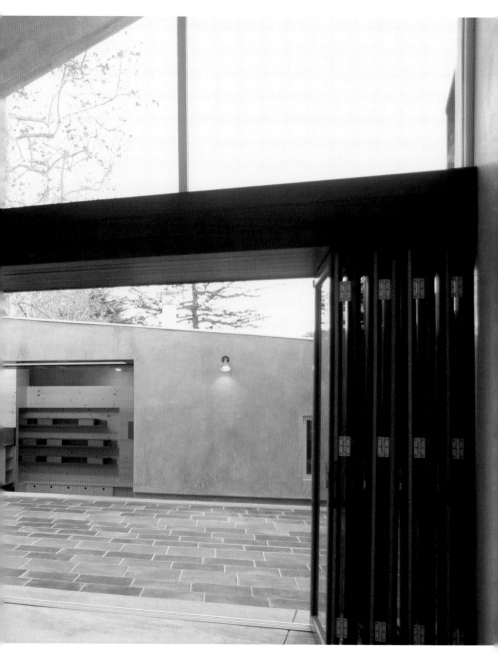

Canal House

Architecture: Sander Architects, LLC
Venice, California, USA
www.sander-architects.com
Photos: Sharon Risedorph

The Canal House consists of a trio of cubes designed for live-work needs. With full-height windows on three sides, the house invites natural light in, with extra efficient insulation helping to keep temperatures consistent. Low-VOC paint and recycled materials add to the green quality of the home.

Das Canal House setzt sich aus drei Kuben zusammen, die gemäß den Bedürfnissen zum Leben und zum Arbeiten konzipiert wurden. Durch auf drei Seiten über die gesamte Höhe des Hauses reichende Fenster fällt natürliches Licht ins Haus und eine energieeffiziente Dämmung sorgt für gleichbleibende Temperaturen. Farben mit niedrigen VOC-Emissionswerten und die Verwendung von Recyclingmaterialien unterstreichen die umweltfreundlichen Eigenschaften dieses Hauses.

La Canal House consiste en un trio de cubes conçus pour les besoins vie-travail. Avec ses baies vitrées sur trois côtés, la maison laisse pénétrer la lumière naturelle et une isolation extrêmement efficace permet de maintenir les températures constantes. Une peinture à faible teneur en COV et des matériaux recyclés contribuent à la qualité verte de la maison.

La estructura de la Canal House se compone de un trío de volúmenes cúbicos diseñados para vivir y trabajar. Los ventanales de cuerpo entero integrados en tres de sus caras dejan paso a la luz natural y un aislamiento eficiente mantiene la temperatura uniforme. El empleo de pinturas de bajo contenido en VOC y materiales reciclados contribuye al carácter ecológico de la casa.

La Canal House consiste di tre cubi progettati per necessità lavorative-abitative. Con finestre a piena altezza su tre lati, la casa invita la luce naturale, con un efficiente isolamento extra che aiuta a mantenere le temperature consistenti. Vernici a basso contenuto di VOC e materiali riciclati contribuiscono alla qualità ecologica.

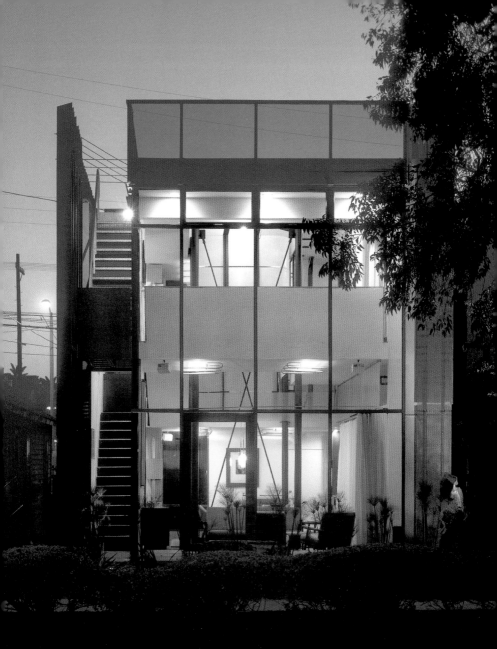

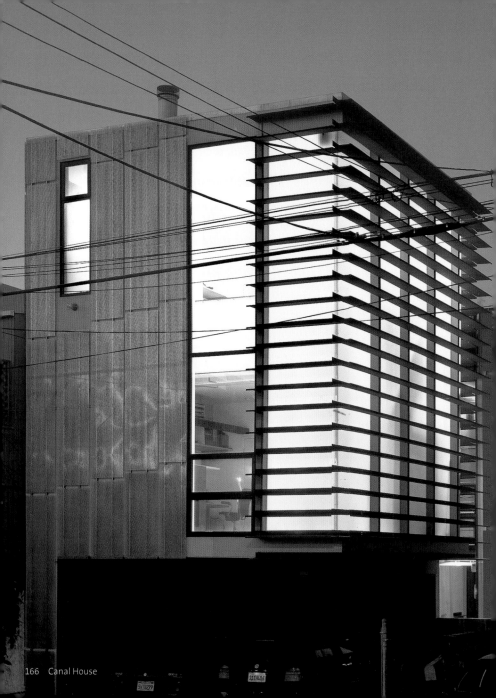

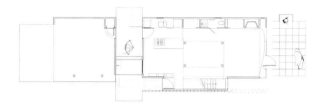

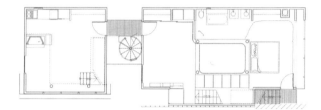

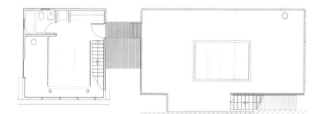

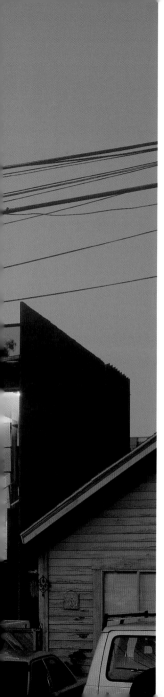

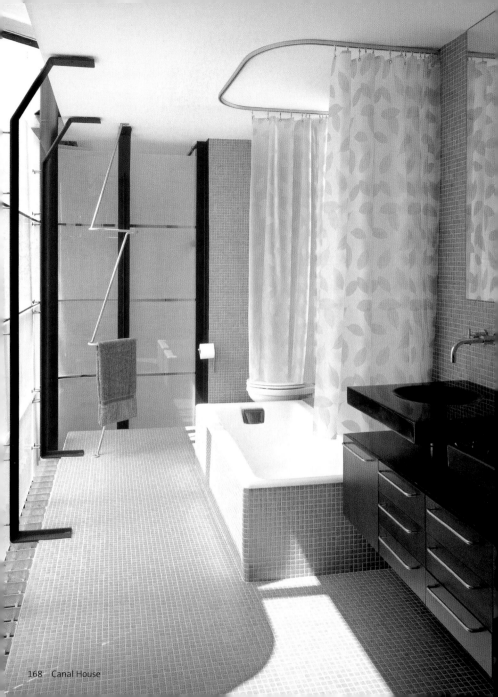

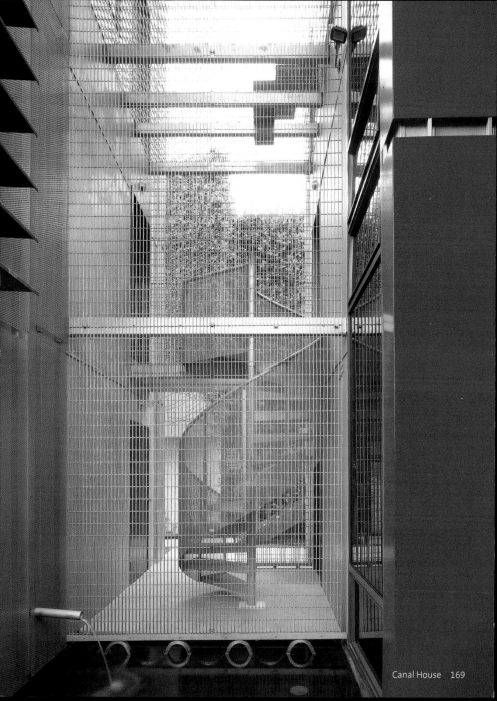

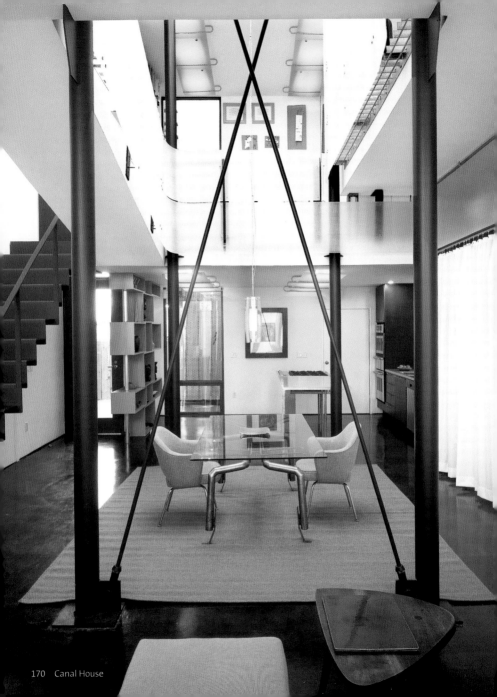

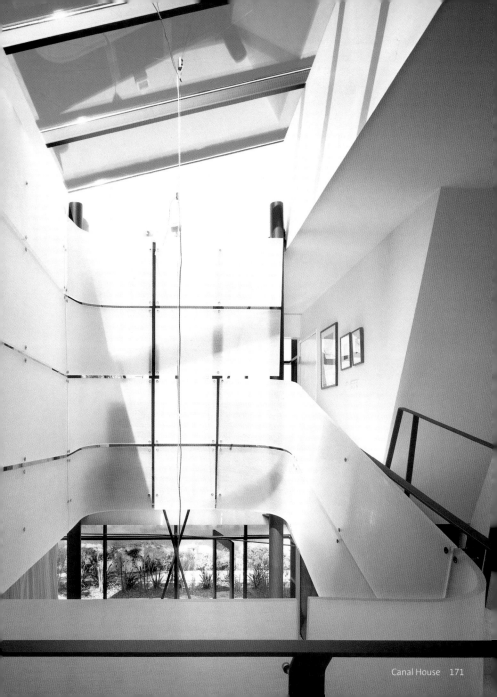

Tree House

<div align="right">Wilmington, Delaware I USA</div>

Architecture: Sander Architects, LLC
Venice, California, USA
www.sander-architects.com
Photos: Sharon Risedorph

The vertically-oriented Tree House embraces and mimics the abundant trees surrounding the site. Under a natural shade canopy, the house boasts a small footprint that keeps disruption to the forest and stream low. Non-toxic wall finishes keep the indoor air as clean as the natural outdoor setting.

Das vertikal ausgerichtete Tree House ist durch den üppigen Baumbestand, der das Grundstück umgibt, inspiriert und imitiert diesen. Das unter einem Schatten spendenden natürlichen Blätterdach gelegene Haus zeichnet sich durch geringe negative Umwelteinflüsse auf den Wald und das Grundwasser aus und durch die Verwendung ungiftige Wandfarben ist die Raumluft ebenso rein wie die der natürlichen Umgebung.

Orientée verticalement, la Tree House englobe et imite les nombreux arbres entourant le site. A l'ombre naturelle de la canopée, la maison affiche un faible encombrement qui ne perturbe ni la forêt ni les eaux. Des finitions de murs non toxiques font qu'à l'intérieur, l'air est aussi pur qu'à l'extérieur, dans le cadre naturel.

Esta casa de orientación vertical se funde con la espesa arboleda que la circunda e imita sus formas. Bajo la sombra natural que ofrecen los árboles, su impacto en el entorno formado por el bosque y un riachuelo es mínimo. El acabado de las paredes a base de productos no tóxicos mantiene el aire interior tan puro como el del entorno.

Orientata verticalmente, la Tree House abbraccia ed imita i numerosi alberi circostanti. Sotto una tettoia naturale, la casa vanta un'impronta ridotta, che mantiene al minimo lo scompiglio nella foresta e nella corrente. Finiture murali non tossiche mantengono l'aria interna pulita quanto lo scenario naturale esterno.

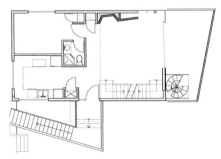

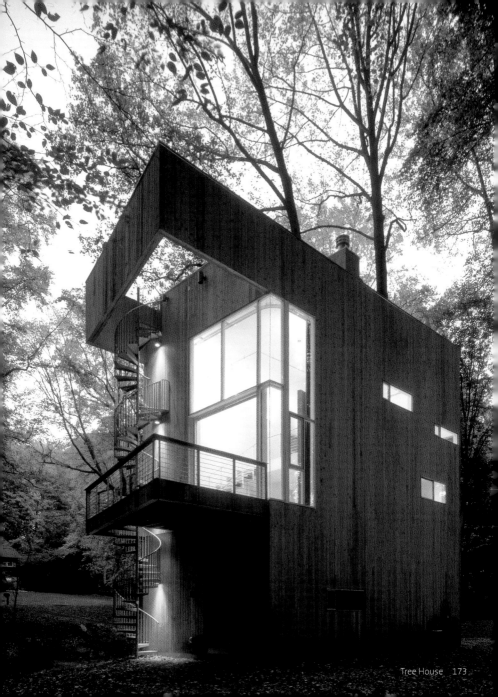

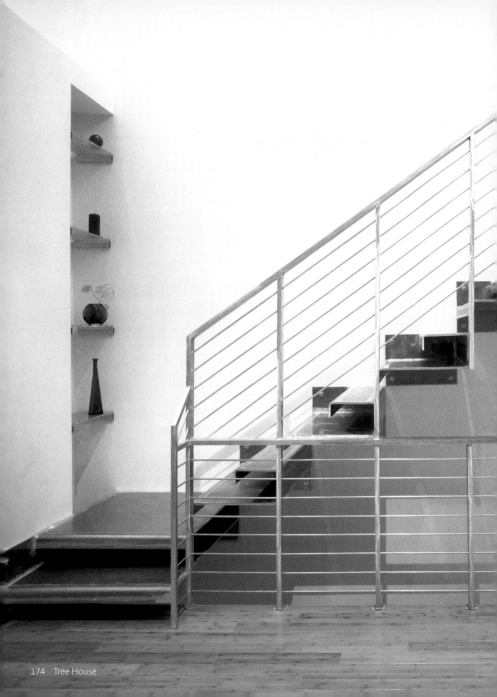

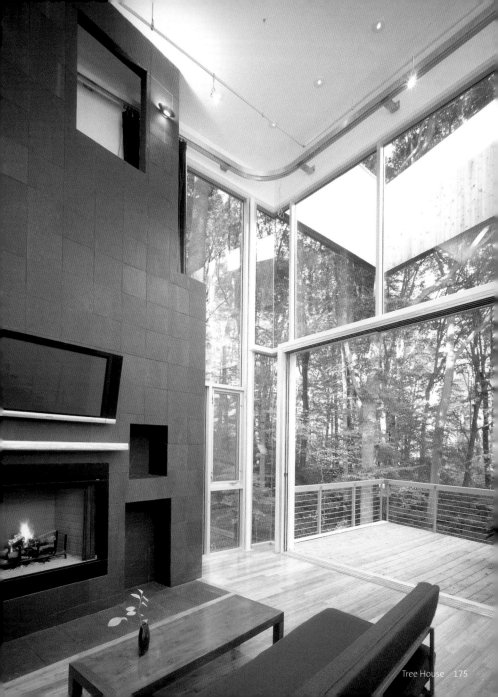

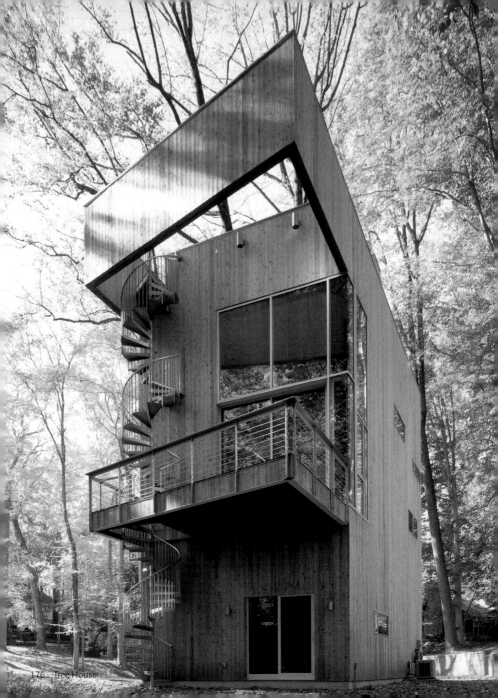

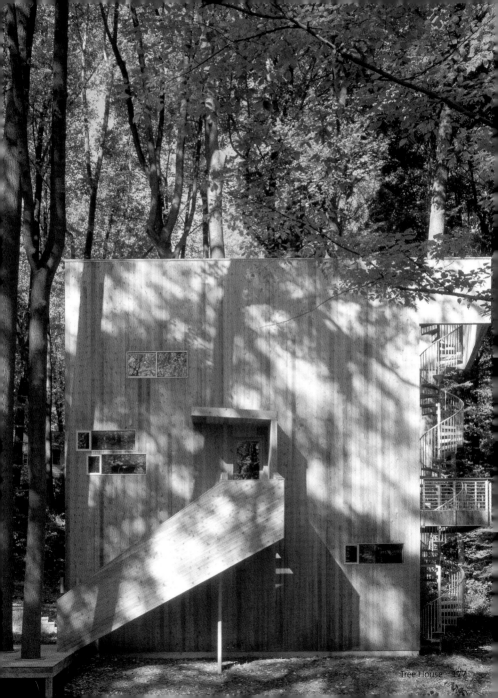

New Residence
at the Swiss Embassy in Washington D.C.

Architecture: Steven Holl Architects
New York City, New York, USA
www.stevenholl.com
Photos: Andy Ryan

Famed architect, Steven Holl, built this home for the Swiss Ambassador to the US. Though necessarily large to accommodate guests, the house meets high standards of sustainability, with the addition of a green roof, photovoltaic panels, passive solar energy, and recycled glass and bamboo flooring.

Der berühmte Architekt Steven Holl baute dieses Haus für den Botschafter der Schweiz in den USA. Obwohl es zwangsläufig groß ist, um Gäste zu beherbergen, erfüllt das Haus hohe Standards in Bezug auf seine Umweltfreundlichkeit. Es besitzt ein begrüntes Dach, benutzt photovoltaische Platten und passive Sonnenenergie und verfügt über Bodenbeläge aus recyceltem Glas und Bambus.

Steven Holl, architecte renommé, a construit cette maison pour l'Ambassadeur de Suisse aux Etats-Unis. Bien qu'assez vaste pour accueillir des invités, la maison répond à des normes élevées de durabilité, avec l'intégration d'un toit vert, des panneaux photovoltaïques, une énergie solaire passive et un sol en verre recyclé et en bambou.

El célebre arquitecto Steven Holl construyó esta casa para el embajador suizo en EE. UU. Si bien había de ser amplia para hospedar invitados, la vivienda alcanza también altos niveles de sostenibilidad al contar con un tejado verde, paneles fotovoltaicos, energía solar pasiva, y suelos de bambú y cristal reciclado.

Il celebre architetto Steven Holl ha costruito questa residenza per l'ambasciatore svizzero negli USA. Pur necessariamente ampia per accogliere ospiti, la casa raggiunge elevati standard di sostenibilità, con l'aggiunta di un tetto ecologico, pannelli fotovoltaici, energia solare passiva, vetro riciclato e pavimenti in bambù.

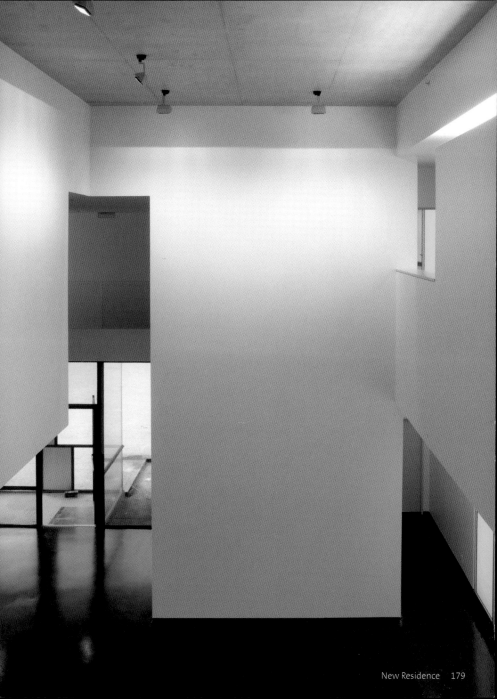

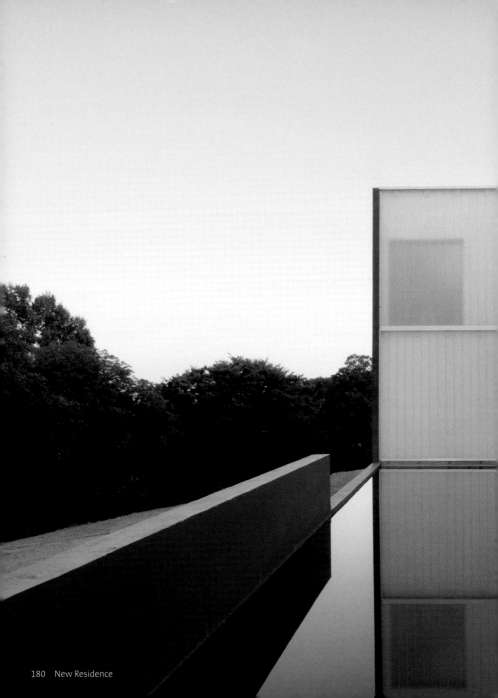

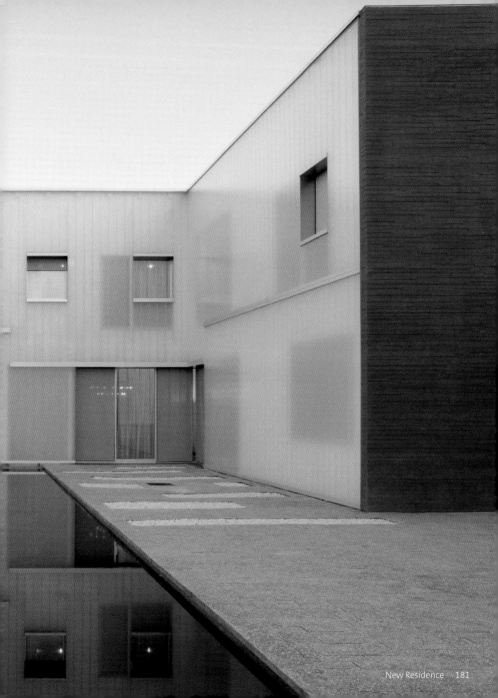

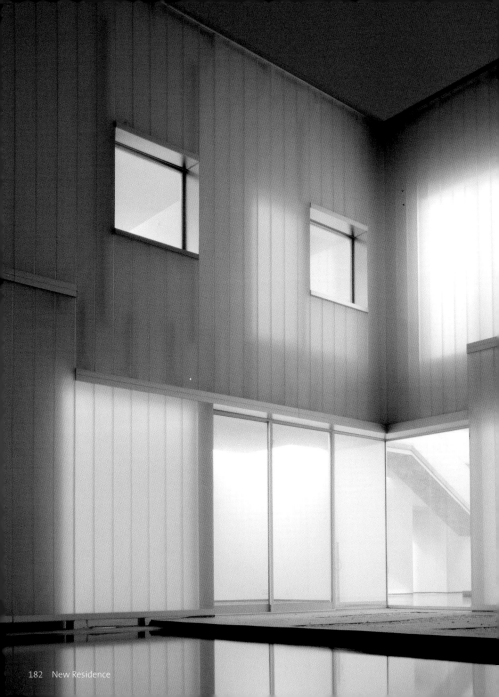

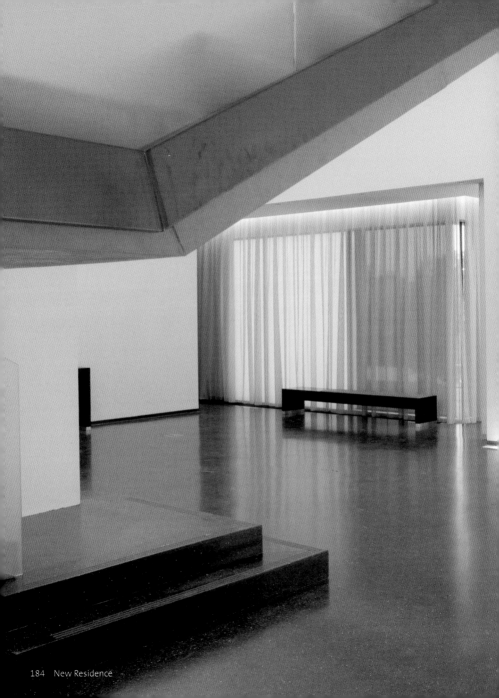

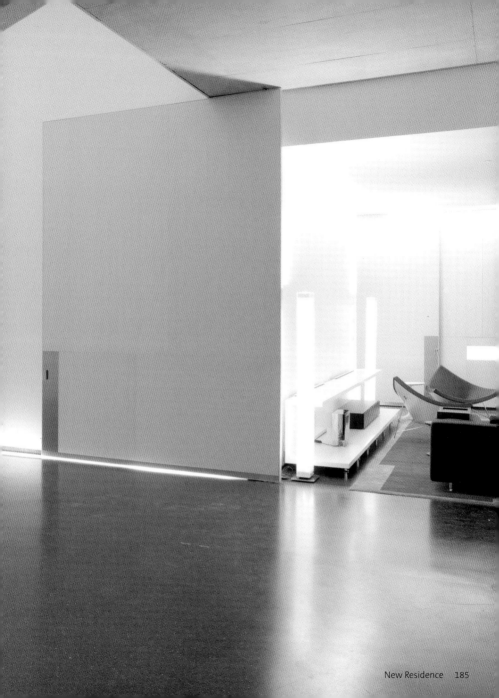

Pirates Bay House

Architecture: Stuart Tanner Architects
Battery Point, Hobart, Tasmania, Australia
www.stuarttannerarchitects.com.au
Photos: Brett Boardman

With the goal of preserving the sense of a seaside shack, the architects imposed as few barriers as possible between the home and the coastal environment. In keeping with the necessary independence of such a structure, the place has contained systems of rainwater collection and greywater recycling.

Mit dem Ziel, den Charakter einer Strandhütte zu bewahren, schufen die Architekten so wenig Barrieren wie möglich zwischen dem Haus und der Küstenlandschaft. Um die Unabhängigkeit einer solchen Konstruktion zu erhalten, verfügt das Haus über ein Regenwasserauffangsystem sowie Grauwasserrecycling.

Avec pour objectif de préserver l'idée d'un abri au bord de la mer, les architectes ont mis le moins de barrières possible entre la maison et l'environnement côtier. Pour assurer l'indépendance nécessaire à une telle structure, le site comporte une installation fermée de collecte des eaux de pluie et de recyclage des eaux usées.

Con el fin de preservar el estilo de una cabaña junto al mar, los arquitectos dispusieron el menor número posible de barreras entre la vivienda y el entorno costero. Para dotar a la estructura de la independencia necesaria, el inmueble cuenta con sistemas propios de almacenamiento de aguas pluviales y reciclaje de aguas residuales.

Con l'obiettivo di mantenere il senso di una capanna in riva al mare, gli architetti hanno imposto il minor numero possibile di barriere tra la casa e l'ambiente costiero. Nel garantire la necessaria indipendenza di una simile struttura, l'abitazione incorpora sistemi di raccolta dell'acqua piovana e riciclo delle acque grigie.

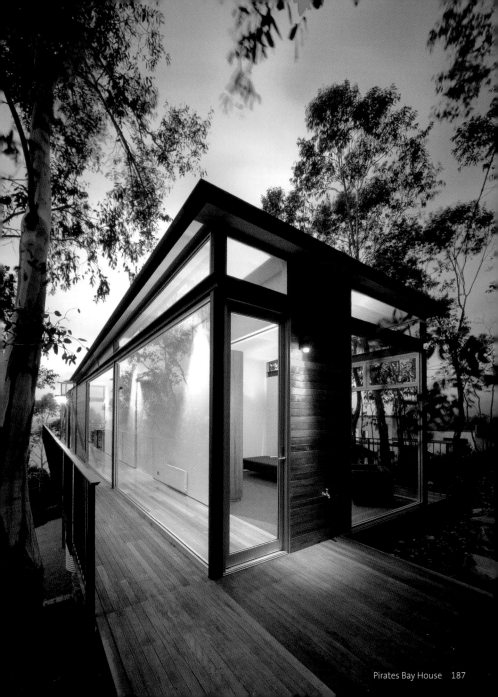

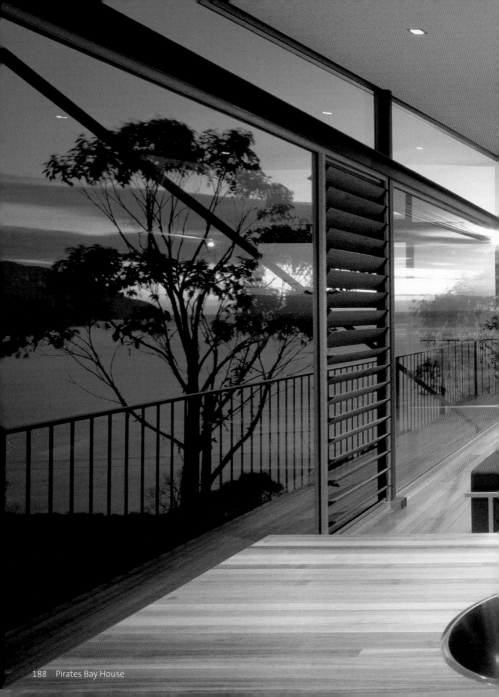

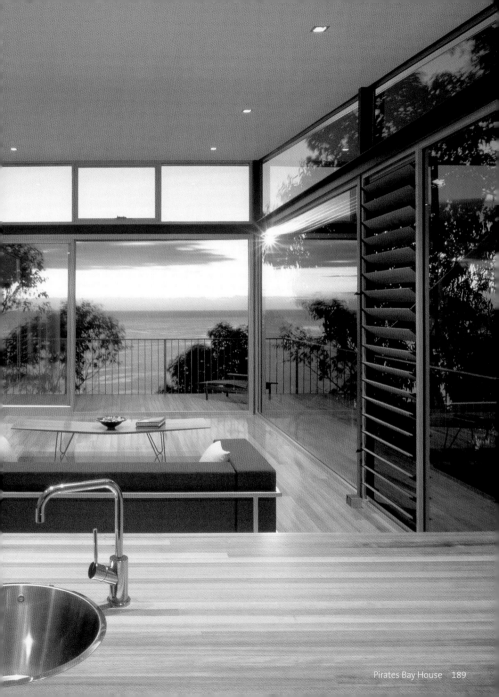

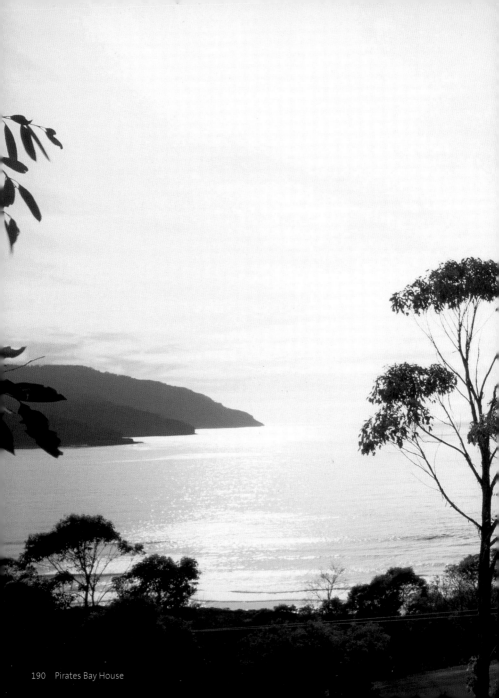

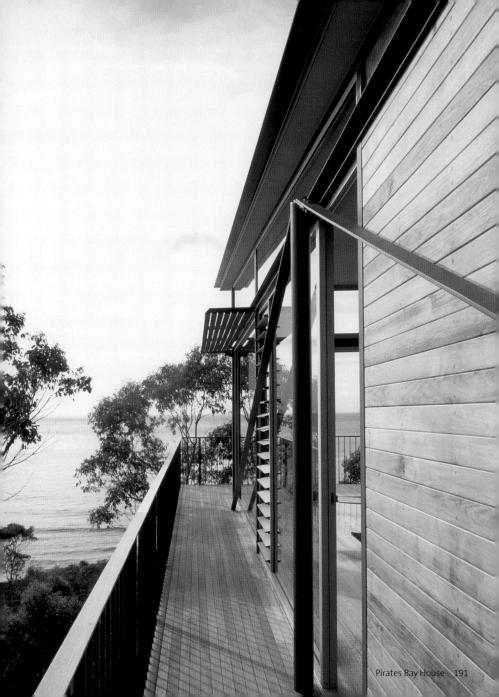

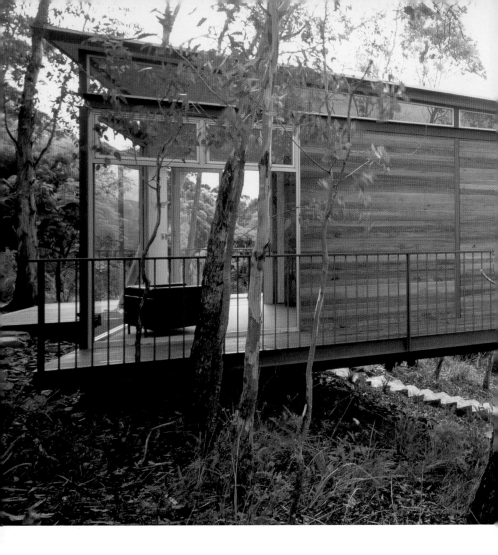

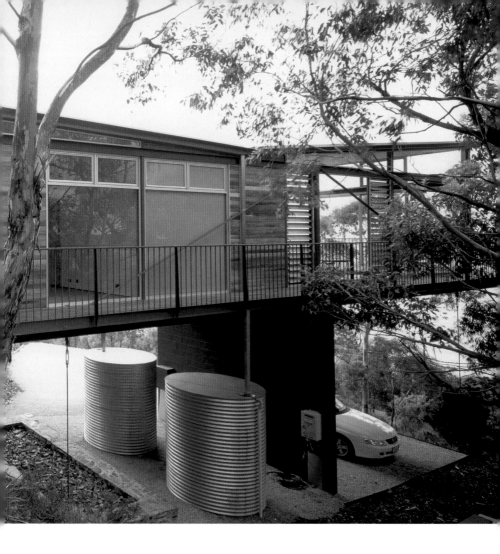

Slavin/Arnholz Residence

Washington, DC I USA

Architecture: Travis Price Architects
Washington, DC, USA
www.travispricearchitects.com
Photos: Kenneth M. Wyner

For this renovation, rather than tear down the existing house, the architects put a modern addition on the aging home. The result is a tall, environmentally-sensitive glass structure with a green roof, natural ventilation, sustainable hardwood floors, rainwater capture and indigenous landscaping.

Um das bereits existierende Haus nicht abreißen zu müssen, fügten die Architekten bei seiner Renovierung einen modernen Anbau an alten Bestand an. Das Ergebnis ist eine hohe, umweltfreundliche Glaskonstruktion mit einem begrünten Dach, natürlicher Belüftung, Hartholzböden aus nachwachsenden Arten, einer Anlage zur Verwertung von Regenwasser und einem Garten mit einheimischen Pflanzen.

Pour cette rénovation, plutôt que de démolir la maison existante, l'architecte a conçu une annexe moderne à la maison vieillissante. Il en résulte une grande structure de verre, sensible à l'environnement, avec un toit vert, une ventilation naturelle, des parquets durables en bois dur, la collecte des eaux de pluie et un aménagement paysager indigène.

En la reforma de esta casa, en lugar de tener que derribar la estructura existente, los arquitectos añadieron un moderno anexo a la antigua edificación. El resultado ha sido una espigada estructura de cristal respetuosa con el entorno, dotada de un tejado verde, ventilación natural, parqué de madera ecológica, almacenamiento de aguas pluviales y paisajismo autóctono.

Per questa ristrutturazione, anziché abbattere l'edificio esistente, gli architetti hanno dotato di un tocco moderno una casa antica. Il risultato è un'altra struttura in vetro ambientalmente sensibile, con tetto verde, ventilazione naturale, pavimenti in tavolato sostenibile, raccolta dell'acqua piovana e panorami autoctoni.

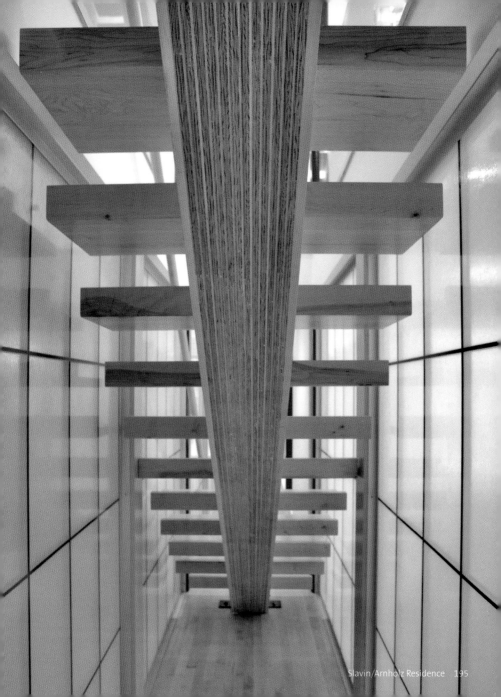

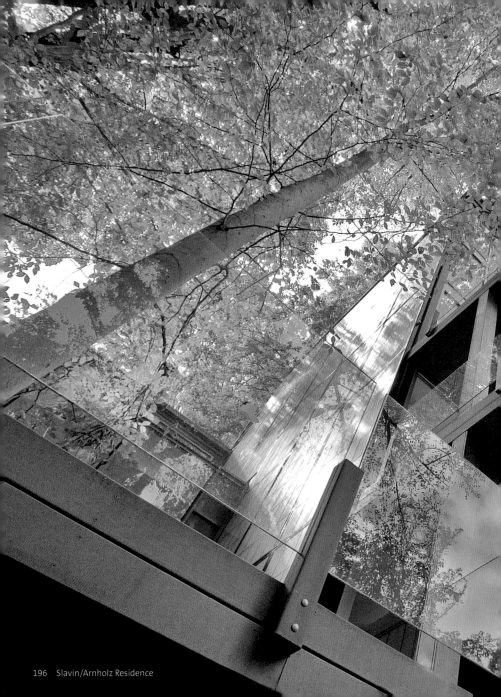

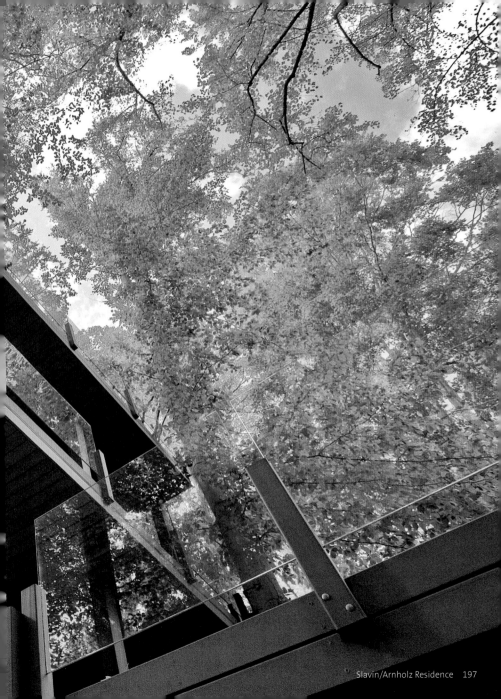

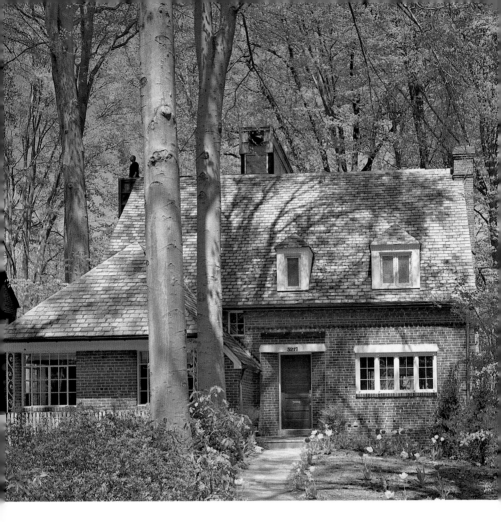

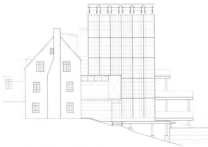
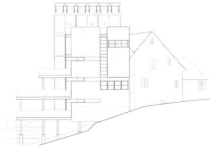

198 Slavin/Arnholz Residence

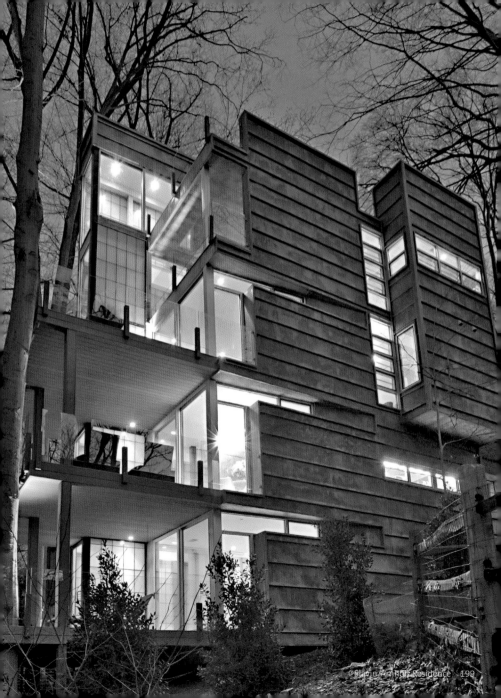

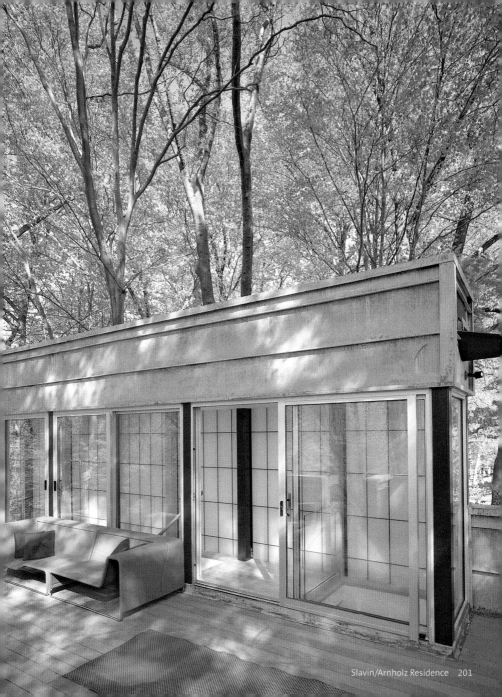

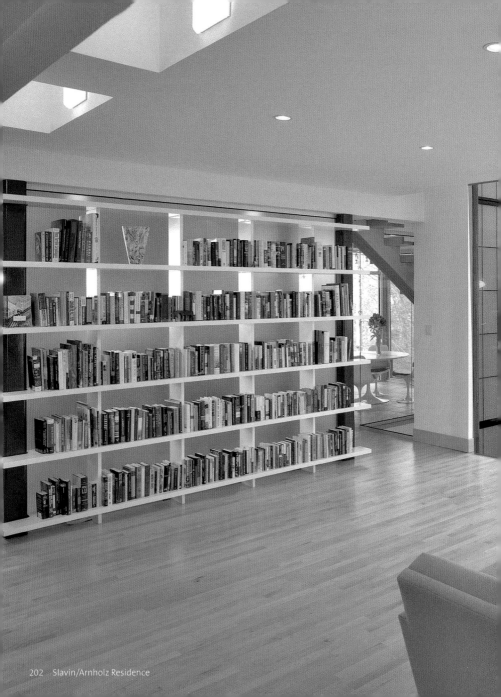

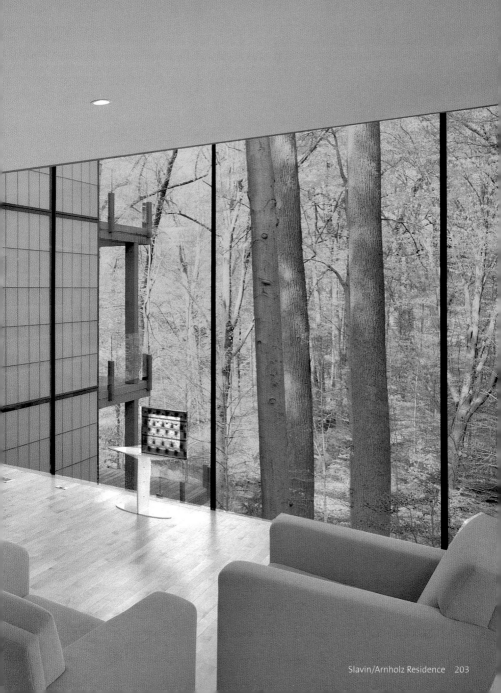

The Linnean Family

Architecture: Travis Price Architects
Washington, DC, USA
www.travispricearchitects.com
Photos: Kenneth M. Wyner

The design of this renovation capitalizes on the modernist style and unique curves of the original home. The super-glazed windows, natural stone and glass tiles, and arched ceilings turn the interior into a series of light-filled chambers, while the exterior enjoys a new coat of galvalume cladding.

Der Entwurf dieser Renovierung profitierte vom modernen Stil und den einzigartigen Rundungen des ursprünglichen Hauses. Durch doppelt verglaste Fenster, Fliesen aus Naturstein und Glas sowie gewölbte Decken verwandelte sich das Innere in eine Reihe von lichtdurchfluteten Räumen, während die Fassade eine neue Verkleidung aus Aluzink erhielt.

Le design de cette rénovation se fonde sur le style moderniste et les courbes uniques de la maison originale. Fenêtres à double vitrage, pierre naturelle, tuiles de verre et plafonds voûtés transforment l'intérieur en une série de pièces remplies de lumière, tandis que l'extérieur est doté d'un nouveau revêtement en galvalume.

El diseño de esta reforma se sustenta en el estilo modernista y las peculiares sinuosidades de la vivienda original. Los grandes ventanales de doble acristalamiento, las baldosas de piedra natural y de vidrio y los techos abovedados transforman el interior en una serie de estancias llenas de luz. El exterior disfruta de un nuevo revestimiento de Galvalume.

Il design di questa ristrutturazione capitalizza lo stile modernista e le curve peculiari dell'edificio originale. Le superfinestre vetrate, la pietra naturale, le piastrelle in vetro e i soffitti ad arco trasformano l'interno in una serie di camere piene di luce, mentre l'esterno dispone di un nuovo rivestimento in galvalume.

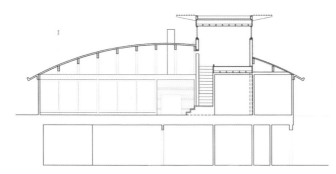

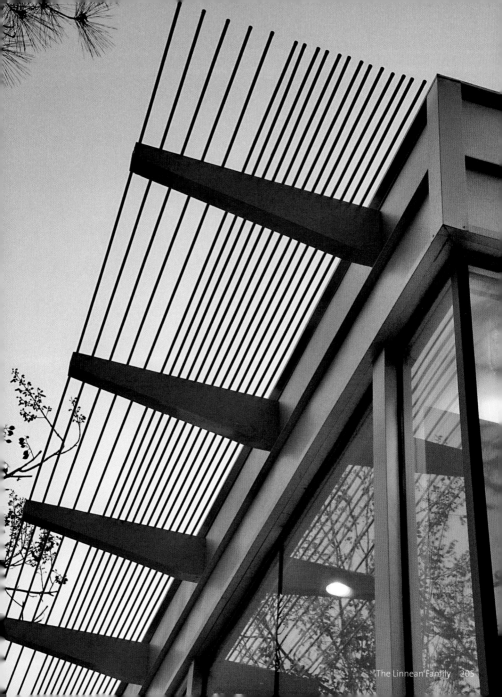

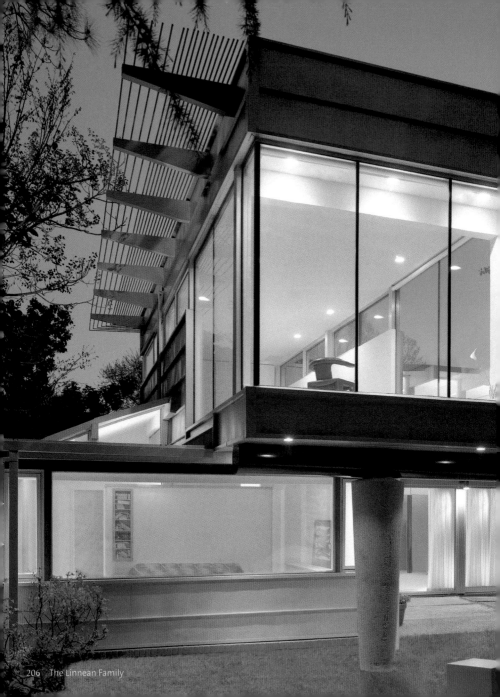

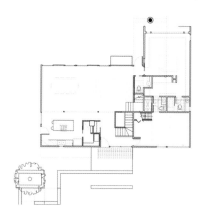

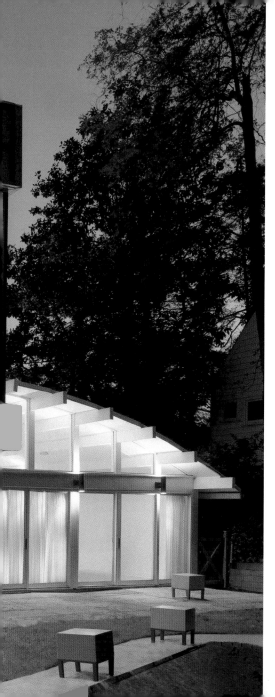

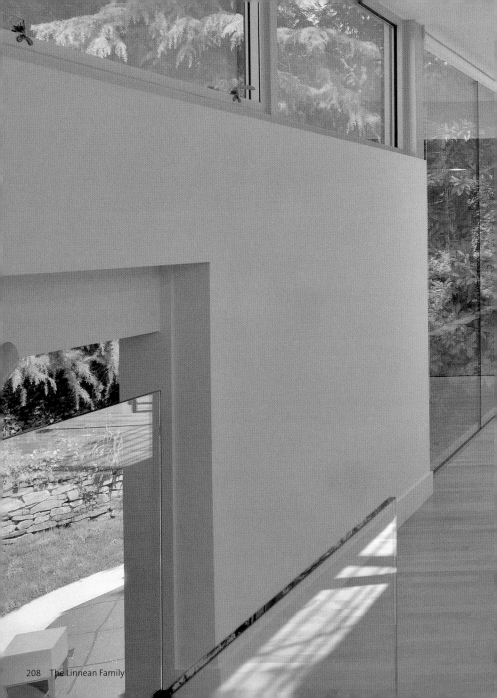

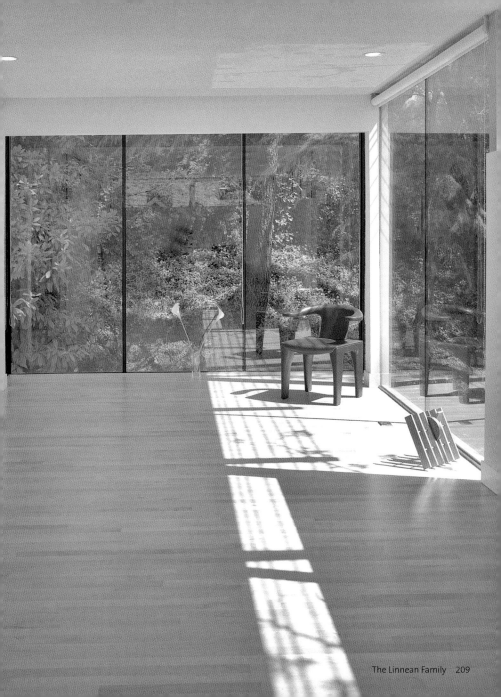

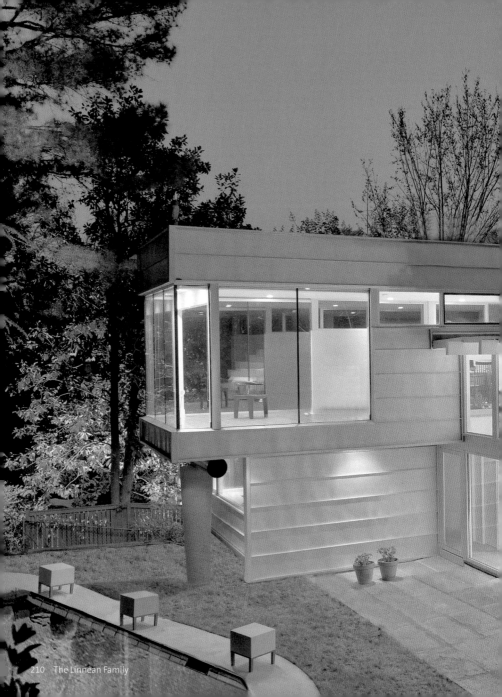

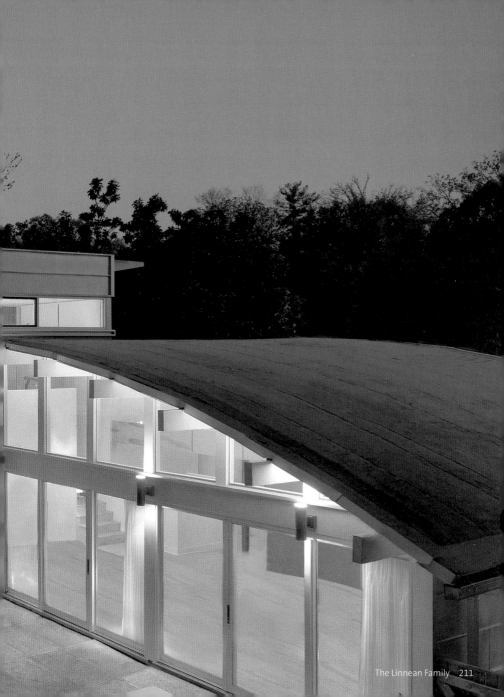

VILLA NM

Architecture: UNStudio
Amsterdam, Netherlands
www.unstudio.com
Photos: Christian Richters

This vacation home sits atop a hill with panoramic views of the landscape. The design honors the site's natural beauty by employing local materials and incorporating earth tones that unify the house with its surroundings. The efficient, glazed windows are tinted golden to match the sky at sunset.

Dieses Ferienhaus befindet sich auf einem Hügel, von dem aus man einen weiten Panoramablick hat. Seine Architektur ist eine Hommage an die natürliche Schönheit des Ortes. Es wurden bewusst einheimische Materialien und Erdtöne eingesetzt, die das Haus mit seiner Umgebung in Einklang bringen. Die energieeffizienten goldfarben getönten Fenster harmonieren bei Sonnenuntergang mit der Farbe des Himmels.

Cette maison de vacances est située au sommet d'une colline avec une vue panoramique sur le paysage. L'architecture rend justice à la beauté naturelle du site en employant des matériaux locaux et en optant pour les teintes de la terre qui relient la maison à son environnement. Les fenêtres vitrées efficaces sont teintées d'or pour s'harmoniser avec le ciel au soleil couchant.

Esta residencia vacacional se asienta en lo alto de una colina con vistas panorámicas. El diseño hace honor a la belleza natural del lugar al utilizar materiales autóctonos e incorporar tonos terrosos que integran la casa en el entorno. Los eficientes ventanales acristalados, tintados en dorado, armonizan a la perfección con el cielo al atardecer.

Questa casa per vacanze è situata in cima a una collina con viste panoramiche. Il design onora la bellezza naturale del luogo, impiegando materiali locali e incorporando i toni della terra, che unificano la casa e i suoi dintorni. Le pratiche finestre vetrate sono in tinta dorata, in tema con il sole al tramonto.

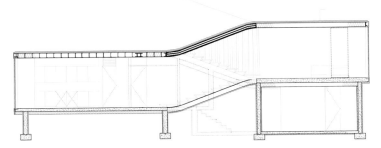

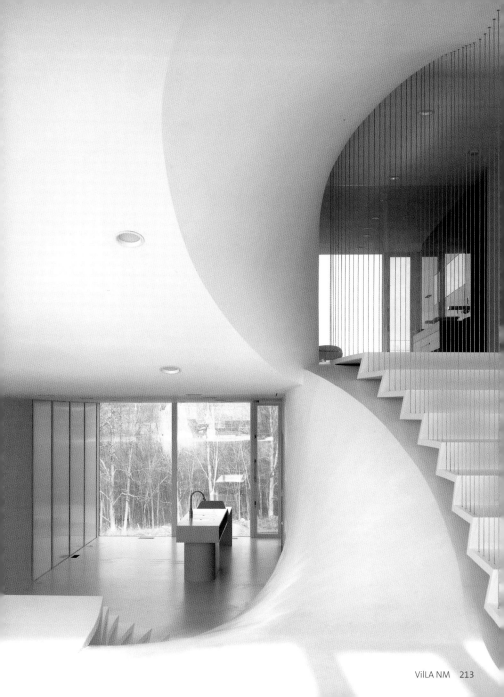

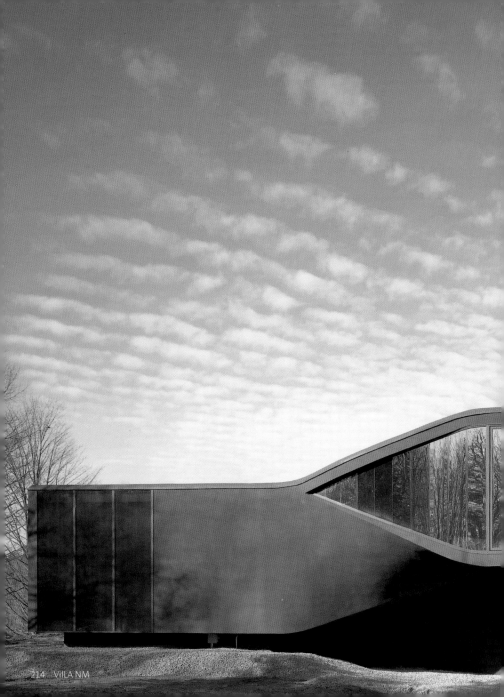

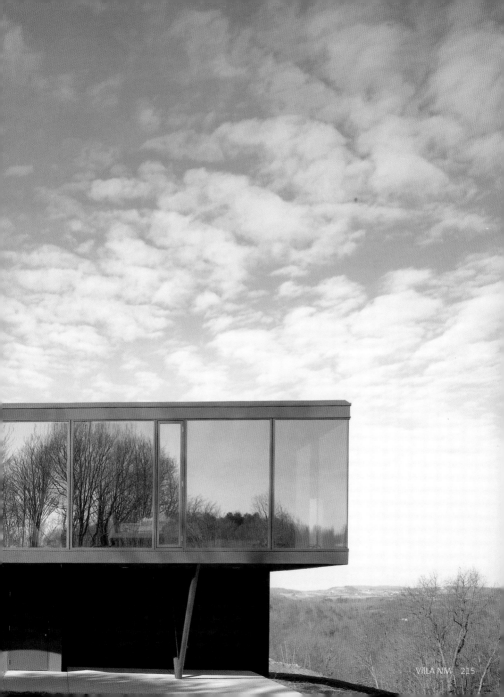

VILLA NM 215

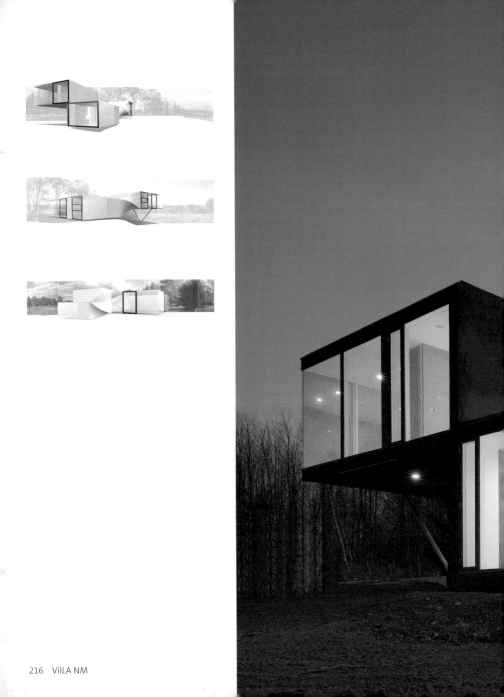

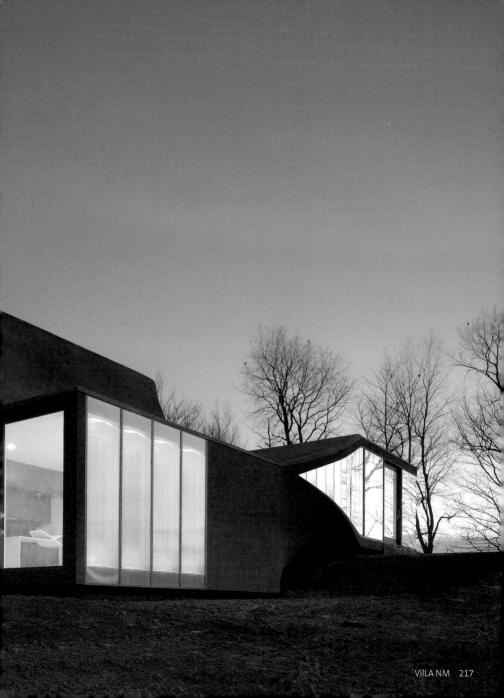

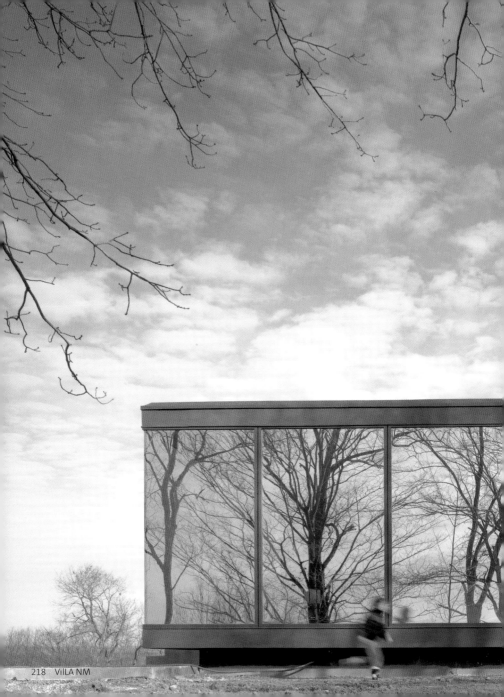

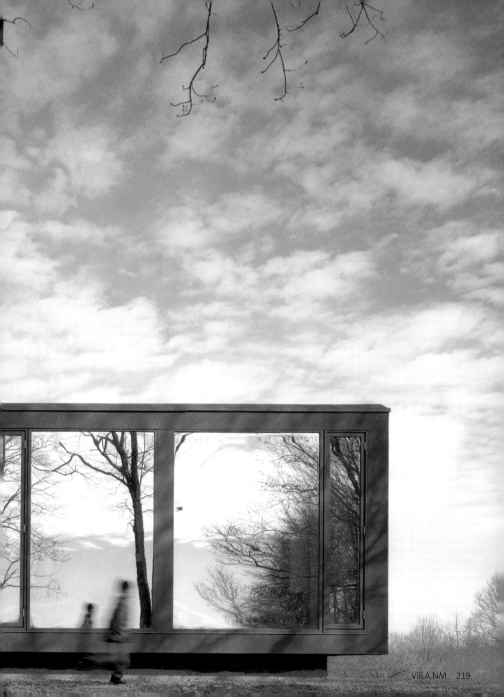

MHOUSE

Architecture: XTEN Architecture
Los Angeles, California, USA
www.xtenarchitecture.com
Photos: Art Gray

In spite of the near-constant sun of its southern California location, the Mhouse has no air conditioning. Using site orientation and the thermal properties of concrete, passive cooling does the trick. The green live-work space also has tankless water heating and landscaping fit for a dry climate.

Trotz der fast permanent scheinenden Sonne besitzt das Mhouse im Süden Kaliforniens keine Klimaanlage. Indem man sich die Gegebenheiten des Ortes und die thermischen Eigenschaften von Beton zunutzte machte, erzielte man gekonnt eine passive Kühlung. Der ökologische Lebens- und Arbeitsraum besitzt auch eine tanklose Wasserheizung und eine auf das trockene Klima ausgelegte Gartengestaltung.

Malgré l'ensoleillement quasi permanent du sud de la Californie où elle est située, la Mhouse ne possède pas de climatisation. Le rafraîchissement passif fonctionne grâce à l'orientation du site et aux propriétés thermiques du béton. L'espace vie-travail vert possède également un chauffage de l'eau sans réservoir et un aménagement paysager convenant à un climat sec.

Pese a que en este lugar del sur de California el sol brilla de forma casi permanente, la Mhouse no dispone de aire acondicionado. La solución perfecta para la refrigeración pasiva consistió en reorientar la casa y aprovechar las propiedades térmicas del hormigón. El espacio verde de trabajo y vivienda cuenta con calentadores de agua sin tanques y el diseño del jardín resulta idóneo para un clima seco.

Malgrado il sole incessante della California del sud, la Mhouse non ha aria condizionata. Affidandosi all'orientamento del sito e alle proprietà termiche del cemento, il gioco è fatto con il raffreddamento passivo. L'area verde, in cui lavorare e vivere, è dotata inoltre di riscaldamento ad acqua senza serbatoio e di un paesaggio adatto ad un clima secco.

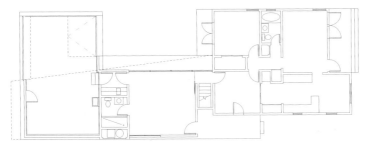

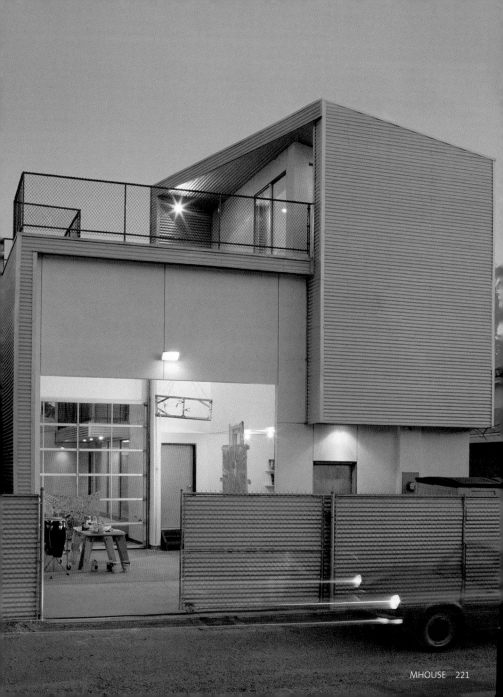

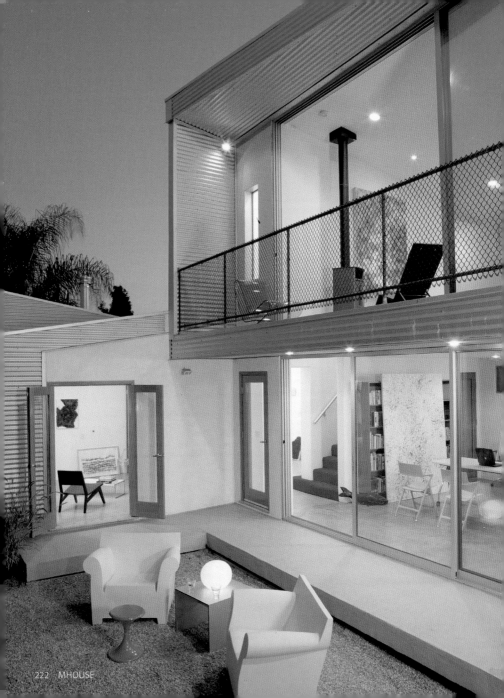

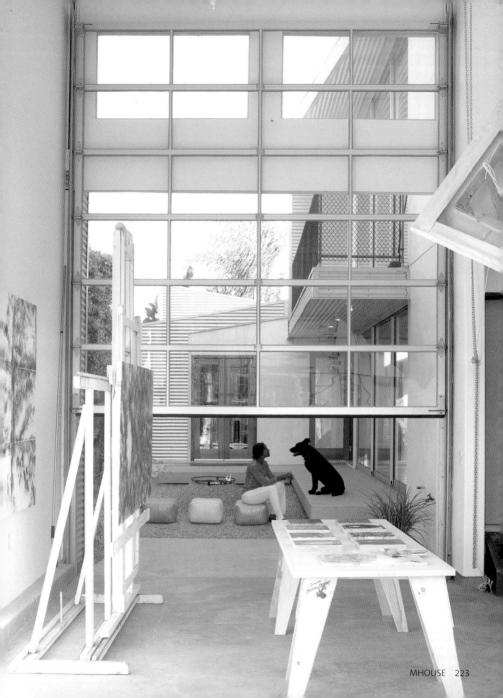

Other titles published in this series

Cool Hotels London
ISBN 978-3-8327-9206-0

Cool Hotels New York
ISBN 978-3-8327-9207-7

Cool Hotels Paris
ISBN 978-3-8327-9205-3

Cool Hotels Italy
ISBN 978-3-8327-9234-3

Cool Hotels Spain
ISBN 978-3-8327-9230-5

Cool Hotels Spa & Wellness
ISBN 978-3-8327-9243-5

Ecological Design
ISBN 978-3-8327-9229-9

Ecological Houses
ISBN 978-3-8327-9227-5

Garden Design
ISBN 978-3-8327-9228-2